ANIMAL LONDON

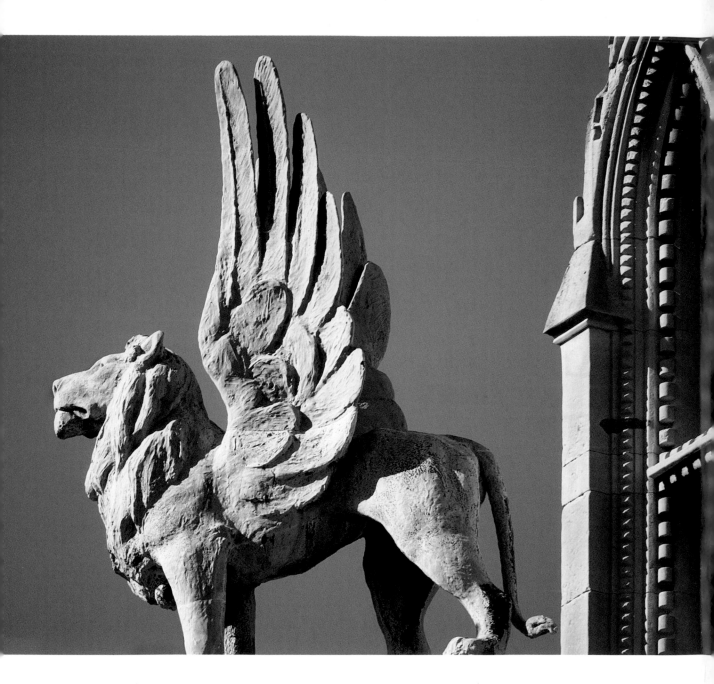

Animal

A SPOTTER'S GUIDE

London

IANTHE RUTHVEN

◨ SQUARE PEG

◼ SQUARE PEG

Published by Square Peg 2011

2 4 6 8 10 9 7 5 3 1

First published in Great Britatin and Ireland in 2011 by Square Peg
Random House, 20 Vauxhall Bridge Road, London SW1V 2SA

www.rbooks.co.uk

Addresses for companies within The Random House Group Limited can be found at:
www.randomhouse.co.uk/offices.htm

The Random House Group Limited Reg. No. 954009

A CIP catalogue record for this book is available from the British Library

ISBN 9780224087049

The Random House Group Limited supports The Forest Stewardship Council (FSC), the leading international forest certification
organisation. All our titles that are printed on Greenpeace approved FSC certified paper carry the FSC logo. Our paper
procurement policy can be found at www.rbooks.co.uk/environment

Design by Anna Crone at www.siulendesign.com

Printed and bound in China by C&C Offset Printing Co. Ltd

To Zephyr and Alexander

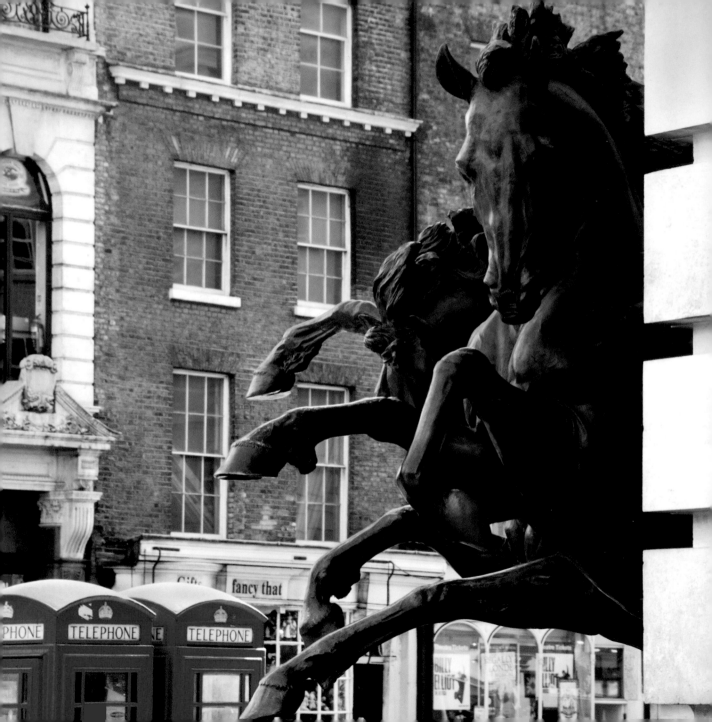

CONTENTS

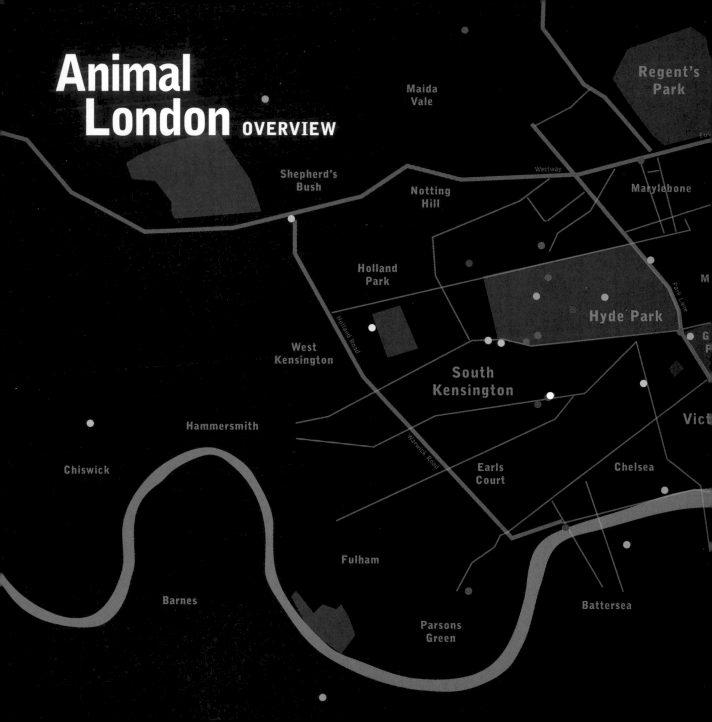

Animal London OVERVIEW

Regent's Park

Maida Vale

Westway

Marylebone

Shepherd's Bush

Notting Hill

Holland Park

Park Lane

West Kensington

Holland Road

Hyde Park

South Kensington

Vict

Hammersmith

Warwick Road

Earls Court

Chelsea

Chiswick

Fulham

Battersea

Barnes

Parsons Green

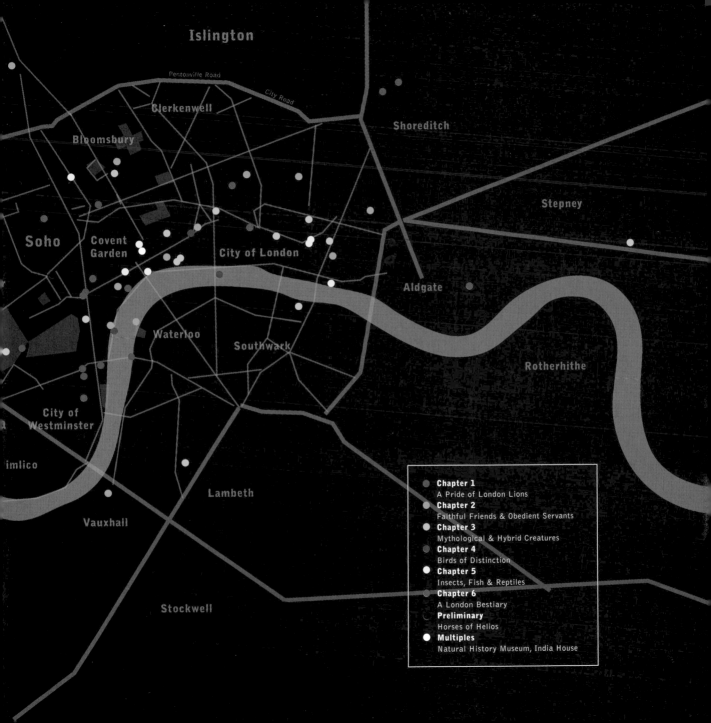

Islington

Pentonville Road

City Road

Clerkenwell

Shoreditch

Bloomsbury

Stepney

Soho

Covent
Garden

City of London

Aldgate

Waterloo

Rotherhithe

Southwark

City of
Westminster

imlico

Lambeth

Vauxhall

Stockwell

Chapter 1
A Pride of London Lions

Chapter 2
Faithful Friends & Obedient Servants

Chapter 3
Mythological & Hybrid Creatures

Chapter 4
Birds of Distinction

Chapter 5
Insects, Fish & Reptiles

Chapter 6
A London Bestiary

Preliminary
Horses of Helios

Multiples
Natural History Museum, India House

Introduction

Strolling down a London street a few years ago, I spotted four fierce sea monsters entwined together against a red brick wall. Then in Westminster I encountered a plasterwork bat propping up a statueless plinth ... and so began my quest for the beasts of London.

Some are well known and attached to famous landmarks, like Landseer's lions in Trafalgar Square or the Quadriga crowning the Wellington Arch at Hyde Park Corner. Others take you by surprise, like the giant graffiti rabbit on Hackney Road that arrests you with its incongruity and wit. Others, perched in gravity-defying positions on churches, office blocks or residential buildings, are virtually impossible to see. Like the Elgin Marbles, they seem to have been intended for gods and birds, but not for human eyes.

How often does anyone actually notice this abundance of creatures that populate the capital? London contains an amazing variety of inanimate animal life. Wandering through the streets and squares of the city, or in its magnificent parks, you can discover a remarkable menagerie. Some are mythical, others real, some stylised formalistically, others observed with an uncannily natural precision. There are rabbits, mice, gorillas, dogs, cats, deer, camels and

elephants; sea creatures such as sharks, sturgeons and dolphins; reptiles including snakes and tortoises; and, among the many birds are eagles, owls and pelicans. Mythological creatures – especially griffins and winged lions – guard the entrances to London's historic centre, while at Crystal Palace prehistoric monsters roam the park. Some of these creatures – such as the dragons guarding the old gateways to the City – reflect an eagerness to draw on heraldic symbolism for civic spaces. Others illustrate the passions and proclivities of builders and entrepreneurs, or the affections of people for their pets.

It would be impossible to include all the animals of London in one small book and there are many I have had to exclude. Where I was obliged to make choices I went for variety and photographic content.

This book pays tribute to generations of architects, designers and sculptors, from the playful medieval craftsmen who originally carved the animals that slide down the flying buttresses of Westminster Abbey, to the inventiveness of the scrap merchants who conjured a menacing 'mechanosaurus' out of automotive body parts. In today's world of headsets and iPhones, with pedestrians oblivious to their surroundings, these creatures are all too easily neglected or ignored. They deserve to be celebrated.

Ianthe Ruthven, 2011

PRELIMINARY PHOTOGRAPHS:

St Mark's lion on the Church of the Good Shepherd, Upper Clapton

One of four bronze statues, symbolizing the evangelists, looking out over the four corners of the earth from the base of the steeple. The church was built by the unconventional Agapemonite cult in 1892 and boasts an array of symbolic statuary which bring William Blake to mind. Nowadays it is used by the Georgian Orthodox Church.

The horses of Helios, Piccadilly Circus

The four bronze horses of Helios, on the corner of Haymarket and Piccadilly Circus, were sculpted by Rudy Weller in 1992. Helios is the Greek god of the sun and he drove his golden chariot across the skies, east to west, everyday.

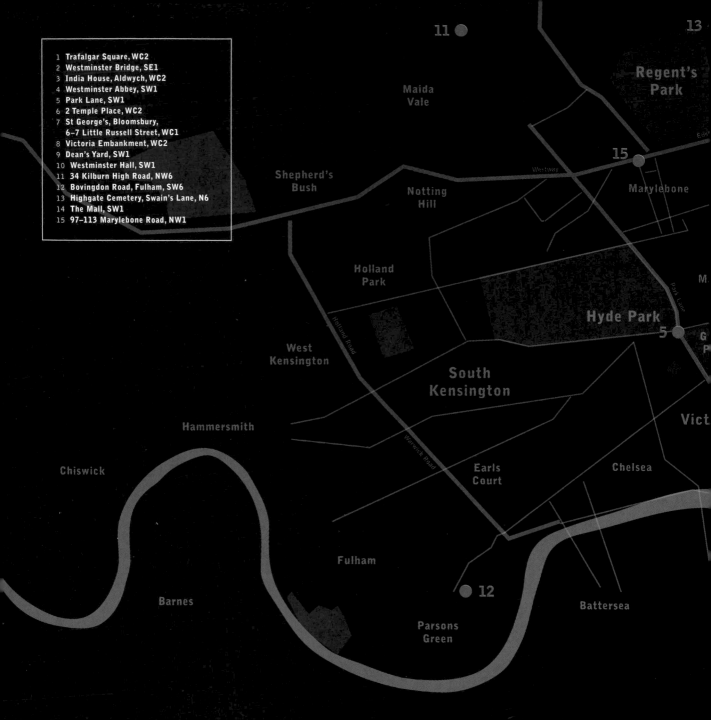

11

13

Regent's
Park

Maida
Vale

15

Westway

Marylebone

Shepherd's
Bush

Notting
Hill

Holland
Park

Hyde Park

5

Holland Road

West
Kensington

South
Kensington

Vict

Hammersmith

Warwick Road

Earls
Court

Chelsea

Chiswick

Fulham

12

Battersea

Barnes

Parsons
Green

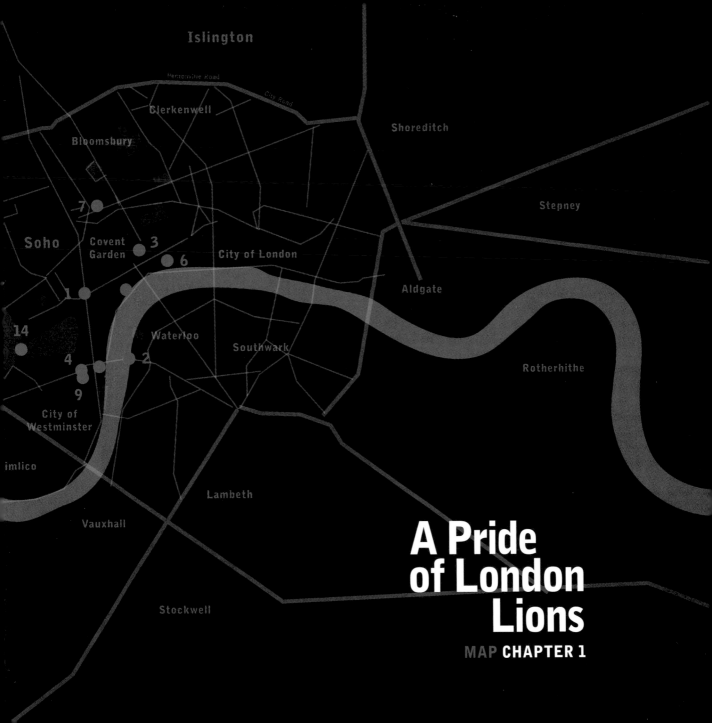

Islington

Pentonville Road

Clerkenwell

City Road

Shoreditch

Bloomsbury

Stepney

7

Soho

Covent
Garden

3

City of London

6

Aldgate

1

14

Waterloo

Southwark

Rotherhithe

4

2

9

City of
Westminster

imlico

Lambeth

Vauxhall

Stockwell

A Pride
of London
Lions

MAP CHAPTER 1

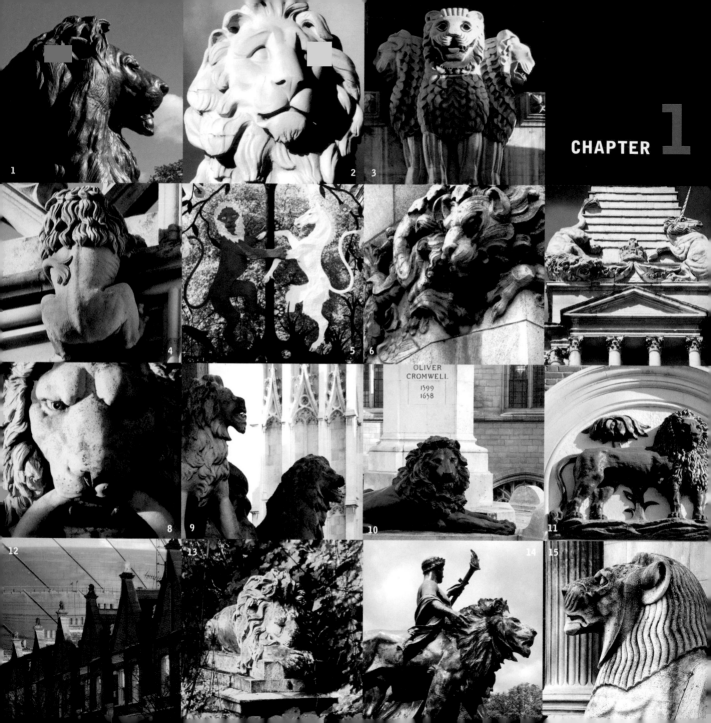

A Pride
of London
Lions

From the earliest times, lions – especially male lions, with their formidable manes and handsome, human-like faces – have been icons of power. Despite, or perhaps because of, its occasional delight in human flesh, the huge carnivorous cat was everywhere seen as proud and noble – the animal everyone wanted on their side. It was the universal symbol for royalty, which is doubtless why aspirant suburban dwellers love to place lions on gates and garden walls.

As the seat of government and once the capital of the world's largest empire, London abounds with lions, from Buckingham Palace and Parliament to humbler town halls and residential dwellings. You can spot them everywhere from street level, guarding wide-flanking steps, to the highest parapets. Their sizes range from modest door-knockers to the huge lions in Trafalgar Square.

Why, we may now wonder, were our forebears so obsessed with this particular creature? In wildlife television programmes the males are exposed as thoroughly indolent and anything but noble, inferior as hunters to their females, and even to much despised predators like jackals and hyenas. Horrible stepfathers, they have a nasty habit of killing cubs engendered by rival males.

So how did the lion gain such an impressive reputation? The *Physiologus*, a book by an anonymous author which dates back to the Dark Ages, and summarizes ancient wisdom about animals, identified the lion as 'king of the beasts'. It was the precursor to the bestiaries – illustrated books popular throughout medieval Europe – which endowed animals with various symbolic moral qualities, with the noblest saved for the lion. No wonder that royalty seized on the animal for its own ends. When the crusader King Richard the Lionheart chose three lions to represent England in 1189, he started a trend. Today the royal coat of arms bears a double image of the three lions, supported by yet another 'English' lion, and the unicorn of Scotland. So persistent is the symbolic power of the lion that it has been adopted by both the English football and cricket teams.

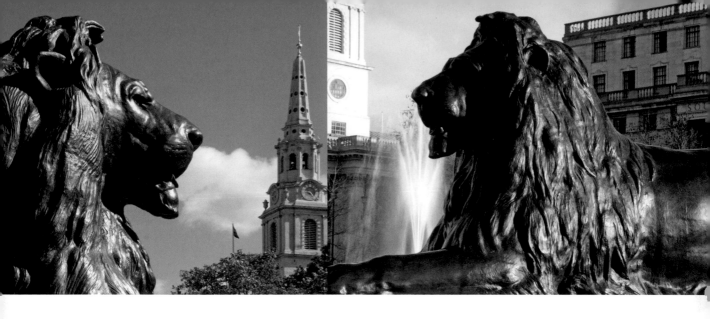

1 Lions, Trafalgar Square

Among the most famous lions in the world, they were commissioned from Sir Edwin Landseer, Queen Victoria's favourite painter, as sentinels to Nelson's Column (erected 1839–43). Each of the four lions is eleven feet high and twenty feet long and was cast at the Morris Singer Foundry. Rumour has it that the metal used was recycled from the cannon of the French fleet.

It is hard to believe that when they were finally set up in 1868 there was a chorus of disapproval, which was only in part the result of Landseer's endless broken promises about the completion dates. It was said that the lion on top of Northumberland House (now demolished) would not acknowledge the new lions as being in any way related, and W.J. Nettleship,

a distinguished animal painter, wrote ungenerously in 1886 that 'the Trafalgar Square lions must be quietly damned because, pretending to be done from nature, they absolutely miss the true sculptural quality which distinguishes the leonine pose, and because a lion couched like that has not a concave back like a greyhound, but a convex back, greatly ennobled in line from the line of a cat's back in the same position.'

But Richard Jefferies, in his book *The Toilers of the Field* (1898), was impressed by 'their calm strength in repose, the indifference to little things, the resolute view of great ones … they are truer and more real, and besides, these are lions to whom has been added the heart of a man.'

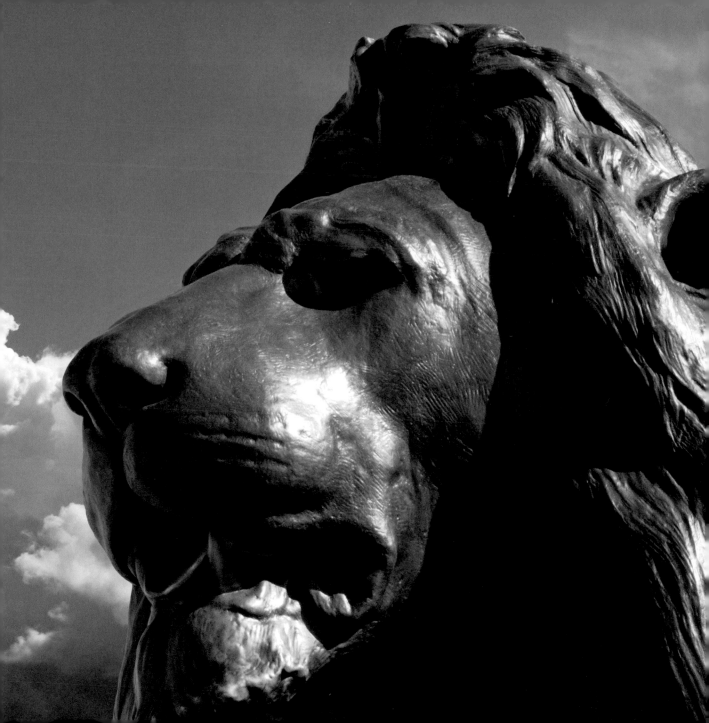

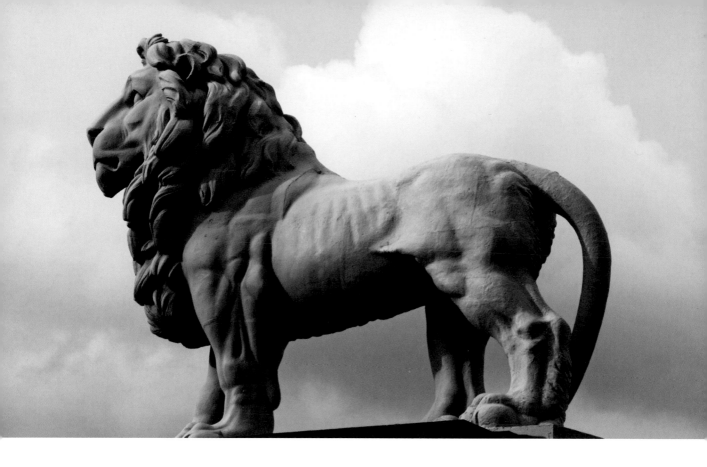

2 Coade lion, Westminster Bridge

In spite of his imposing location, the 13-tonne coade lion at the eastern end of Westminster Bridge wears a slightly sardonic expression veering on the jocular. Everyone loves him. Could this be a consequence of his original association with the Lion Brewery on the South Bank where he presided from 1837 on the roof parapet? One hundred and thirteen years of brewing beer wafting upwards must surely have had its effect. Sculpted by W.F. Woodington, he is made of coade,

a secret ceramic formula invented by Eleanor Coade. When the brewery was demolished in 1950 to make way for the Royal Festival Hall, the lion was saved at the request of no lesser person than King George VI. He was painted glossy red and mounted on a plinth outside the Waterloo Station entrance to the Festival of Britain site. When the station was enlarged in 1966 he was stripped of his red coat and relocated to his present site.

3 **Lions, India House, Aldwych**

The four lions atop the pillar in front of India House are the official emblem of India. They derive from the Lion Capital erected by the great Emperor Ashoka (304–232 BC), at Sarnath in Uttar Pradesh, to mark the spot where Buddha gave his first teachings, and Buddhism was founded. The four lions (one hidden from view) symbolize power, courage, pride and confidence. They rest on an abacus girded by four smaller animals guarding the four cardinal directions: lion of the north, elephant of the east, horse of the south and bull of the west.

The Lion Capital was adopted as India's National Emblem on 26 January, 1950 – the day it became a republic. It appears on all Indian currency and the official letterhead of the Government of India.

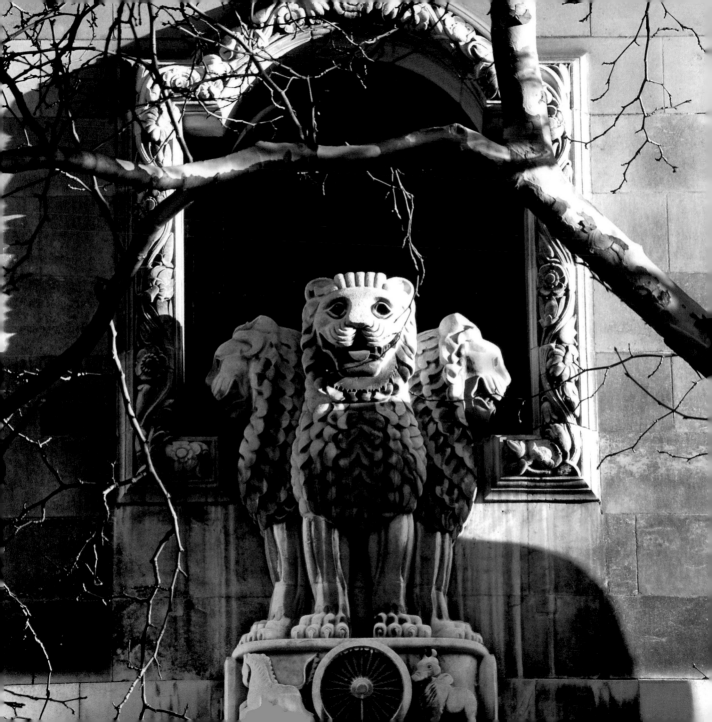

4 Lions, Westminster Abbey

High on the roof of Henry VII's Chapel, lions and other small creatures frolic, using the flying buttresses as slides. Two others are trying to scale the parapet above. It never occurred to me that they were anything other than fine examples of medieval playfulness until I discovered they were carved between 1992 and 1995 as part of a restoration programme under Donald Buttress.

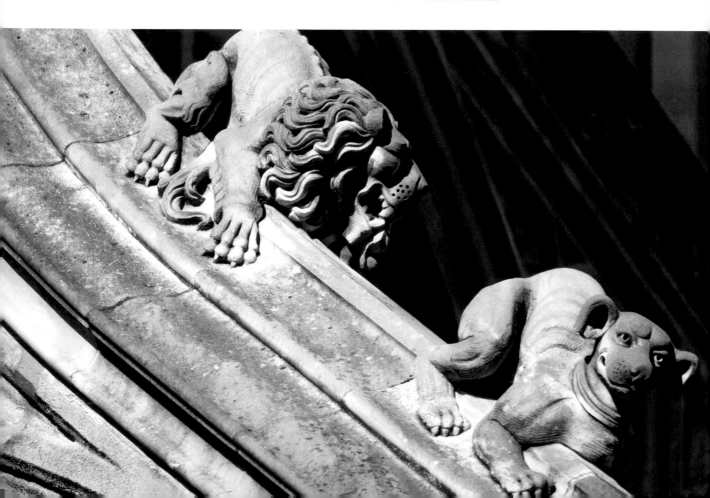

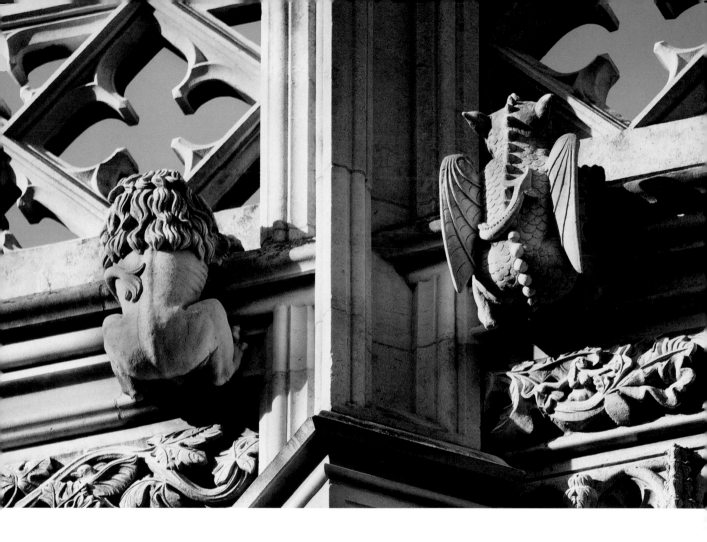

Taking their inspiration from photographs of the originals and working with Portland stone, the sculptors recreated – with a little artistic license here and there – an array of squat creeping beasts, including lions. They had seven carvers working flat out for four years.

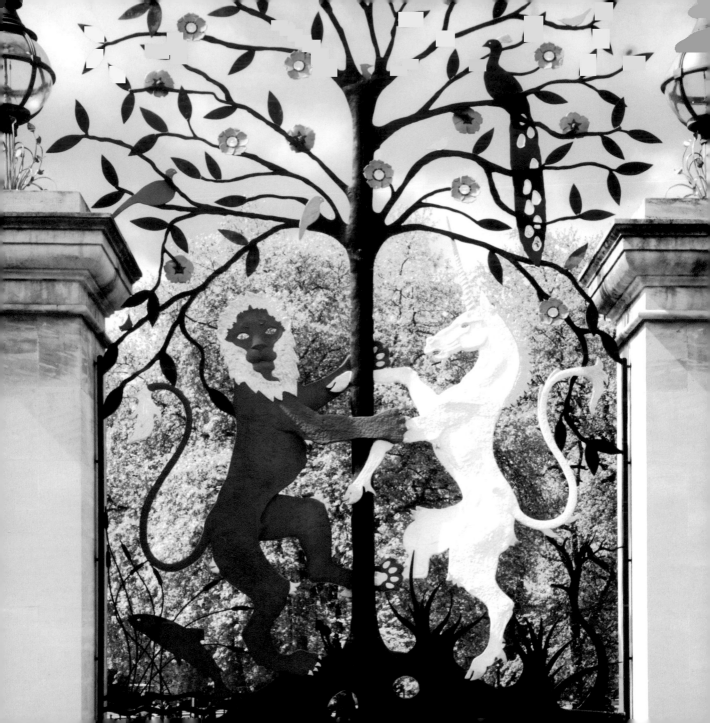

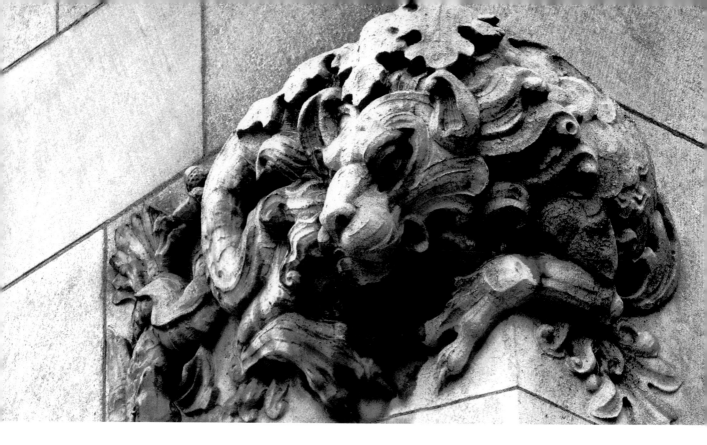

5 The Queen Elizabeth Gates, Hyde Park Corner

Erected to commemorate the Queen Mother, they were opened by HM the Queen in 1993. The central screen was designed by David Wynne.

6 Crouching lion, the Embankment

This exuberant lion straddles one of the corners of 2 Temple Place. It was built in 1895 for the 1st Viscount Astor, to the elaborate architectural specifications of John Loughborough Pearson. The house, like the carving, embodies much of the outstanding workmanship and attention to detail that characterized the late Victorian period.

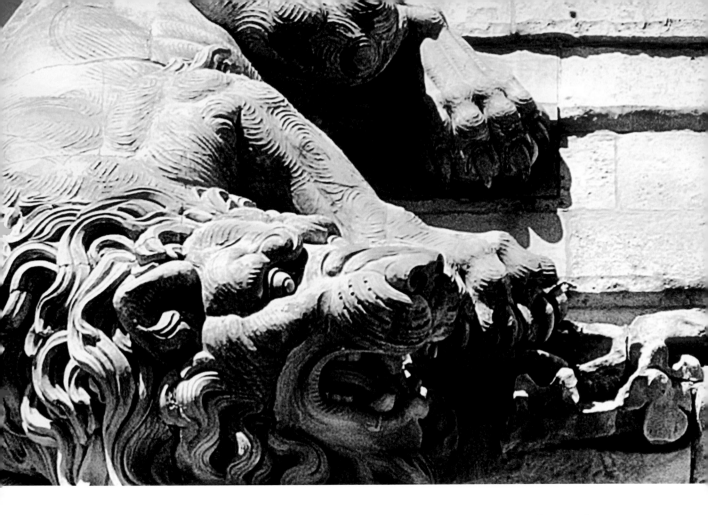

₇ **Lion and unicorn, St George's, Bloomsbury**

The Lion and Unicorn were fighting for the crown.
The Lion beat the Unicorn all around the town.
Some gave them white bread,
and some gave them brown;
Some gave them plum cake
and drummed them out of town.

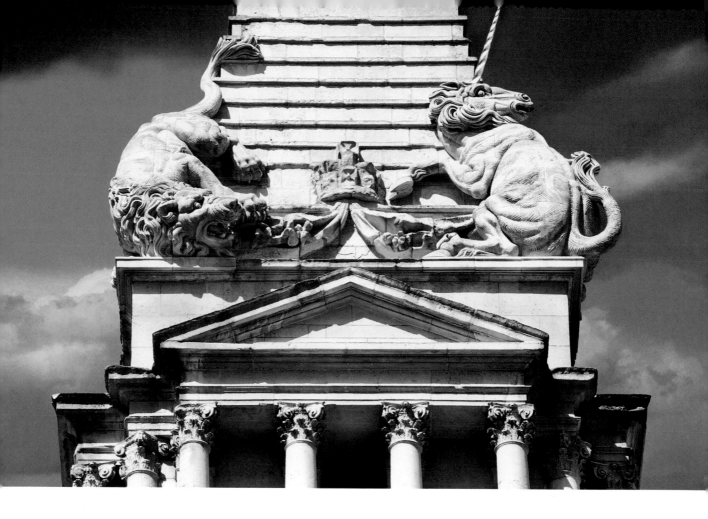

There are so many images of lions and unicorns in London that you might be forgiven for passing them over. But these, based on Hawksmoor's originals, are different. Dynamically posed and aggressive, the beasts – like the eighteenth-century nursery rhyme – may refer to the competing interests struggling for the crown of the United Kingdom at the time of the Jacobite rebellion and the Hanoverian succession.

The original sculptures were removed from the base of the spire in 1870, supposedly because they had become unsafe. The spire was said to have been inspired by the Mausoleum at Halicarnassus – one of the Seven Wonders of the World – and the four sculptures round its base, each one ten foot three inches high, were probably built into the stone.

With the help of the World Monument Fund they were recreated by sculptor Tim Crawley and finally set into position in 2006.

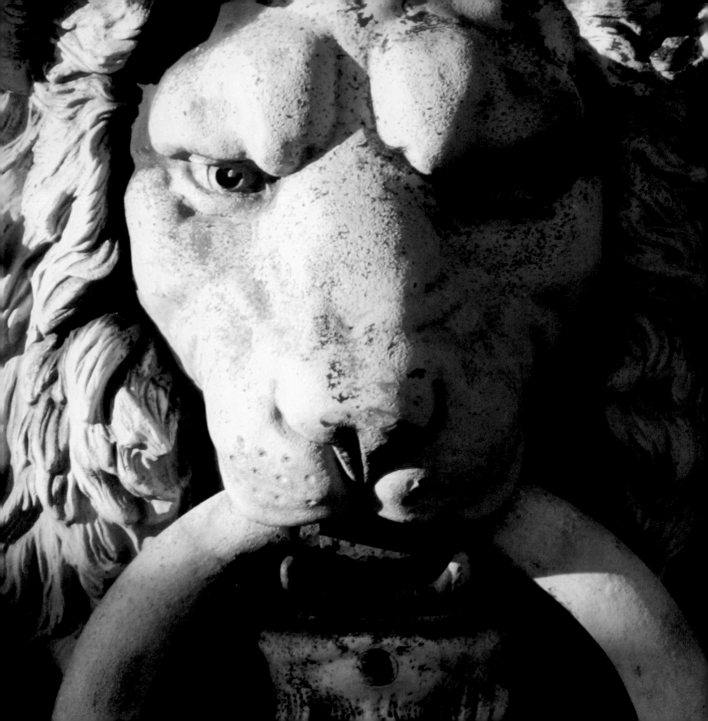

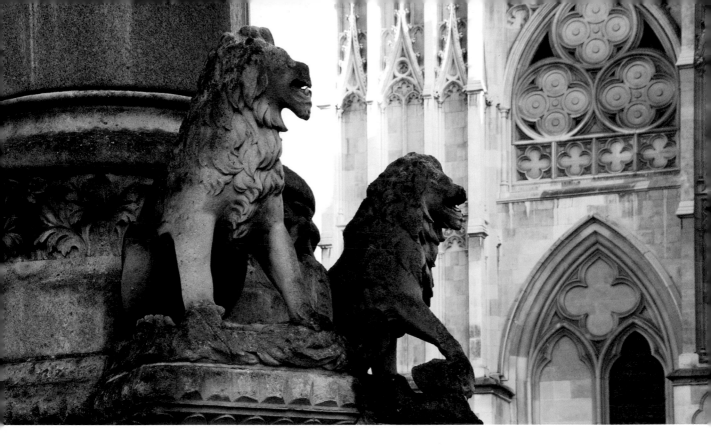

8 Lion-mask mooring rings, Victoria Embankment

One of many lion mooring rings designed by Timothy Butler lining both sides of the Victoria Embankment. The Embankment was constructed between 1864 and 1870, along with major sewage works created by Sir Joseph Bazalgette in response to the 'Great Stink' arising from the Thames during the hot summer of 1859.

9 Westminster School War Memorial

This memorial (by Sir George Gilbert Scott) was erected by the alumni of Westminster School 'in full assurance that the remembrance of their heroes in life and death will inspire their successors at Westminster with the same courage and self devotion.' Detail of two lions guarding the memory of those who died in the Russian (Crimean) and Indian (the Great Mutiny) Wars between 1853 and 1858. Westminster, established in 1179, is England's oldest public school.

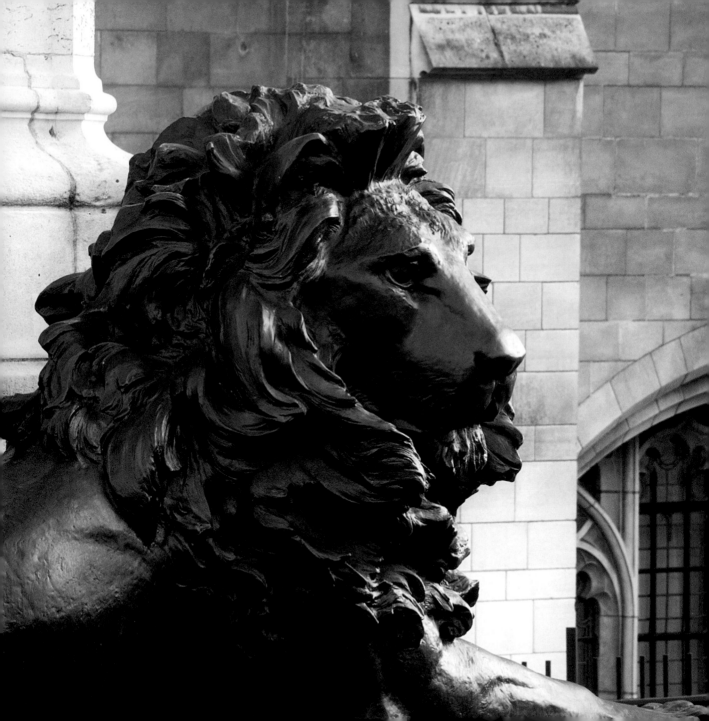

10 Lion under the statue of Oliver Cromwell, Westminster Hall

After recent cleaning, the date 1899 was found on the paw of the lion, while the sculpture of Cromwell is signed 'Hamo Thornycroft 1895–9'.

11 Red Lion, Kilburn High Street

An ancient guesthouse once stood on this site. More recently it housed the Red Lion pub until its name was changed to the Westbury. Above the lion statue is a plaque which says 'Established 1444'.

12 **Gabled lions, Fulham**
View of Bovingdon Road, SW6, with lion-crowned gables and Sands End gas works.

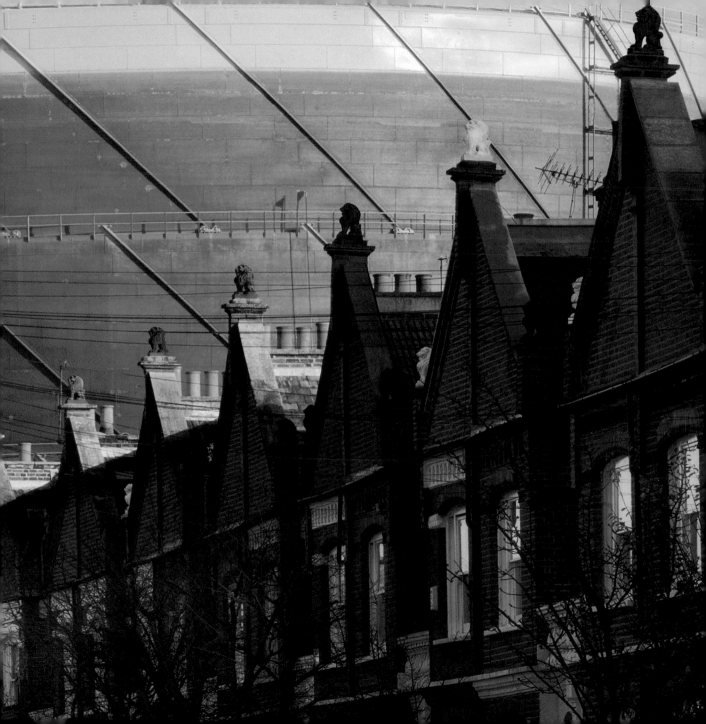

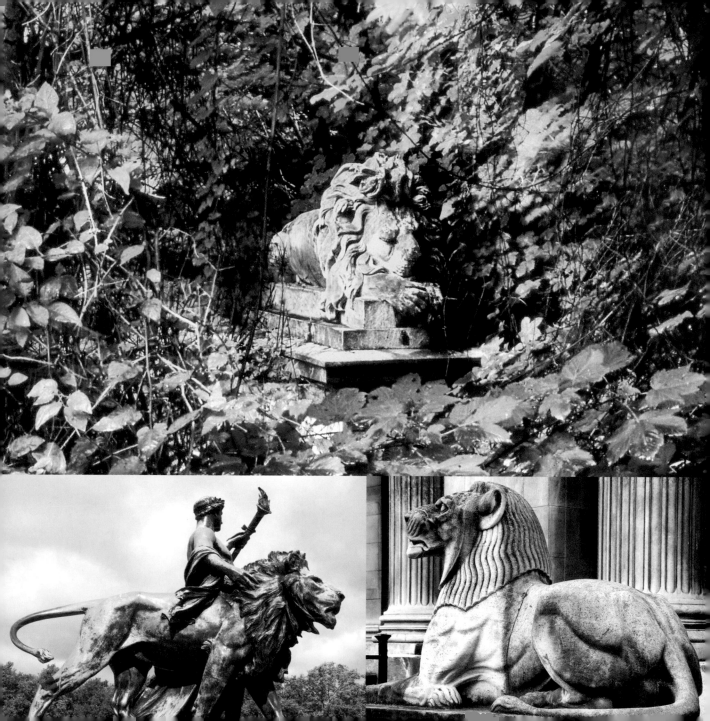

13 George Wombwell's lion, Highgate Cemetery

George Wombwell is one of the more colourful characters biding his time in Highgate Cemetery. Born in Essex in 1777, he later came to London and discovered there was money to be made from exhibiting exotic animals. These he bought from ships coming from Africa, Australia and South America. His collection included elephants, giraffes, a gorilla, a hyena, kangaroos, leopards, six lions, llamas, monkeys, three tigers and a rhino, as well as panthers, ostriches and zebras. In 1810 he founded the Wombwell Travelling Menagerie and began touring the fairs of Britain. By 1839 it totalled fifteen wagons and was accompanied by a fine brass band. Wombwell raised the first lion to be bred in captivity, whom he named after the Scottish hero William Wallace. But his favourite was the gentle Nero, whose statue sits on Wombwell's grave in Highgate where he was buried in 1850.

14 Victoria Memorial, the Mall

One of four large bronze lions overseeing the stairways leading up to the monumental statue of Queen Victoria in front of Buckingham Palace. The memorial was unveiled in 1911 by Sir Thomas Brock and the surround was constructed by the architect Sir Aston Webb from 2,300 tons of white marble. Appropriately it has earned the nickname 'The Wedding Cake'.

15 Lion on steps of Old Marylebone Town Hall

The Old Marylebone Town Hall is now a registry office and the venue of choice for many celebrity weddings from the Beatles onwards. It is an outstanding example of early twentieth-century municipal architecture with its magnificent tower and arcaded, stepped entrance, guarded by a pair of stone lions.

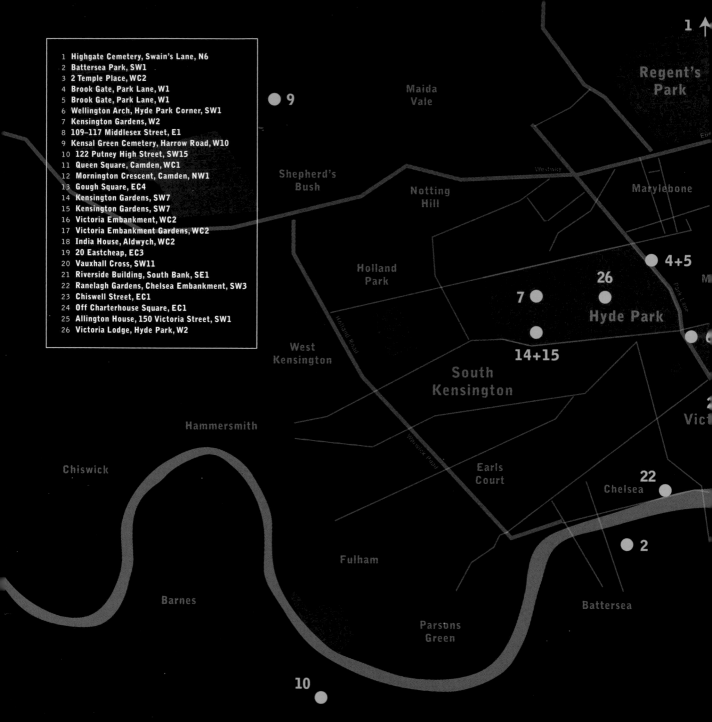

Faithful Friends and Obedient Servants

MAP CHAPTER 2

Faithful Friends and Obedient Servants

Of all of the domestic animals that adorn London's streets the most prominent is the horse. This splendid creature's speed and manoeuvrability made it the military vehicle of choice until the end of the nineteenth century. Horses pulled chariots and other instruments of war, and later formed the basis of cavalries, the most prestigious military arm in Europe for several centuries. Kings and commanders are invariably immortalized with equestrian statues – so many, indeed, that they would take up several books of their own. For that reason, I have taken the decision to exclude horses with riders. It is a pity we know so little about the particular animals who served as props for royalty and power. Yet whilst the horse lends prestige to its rider, the dog is our most trusted admirer and friend. As the novelist Aldous Huxley put it: 'To his dog, every man is Napoleon.'

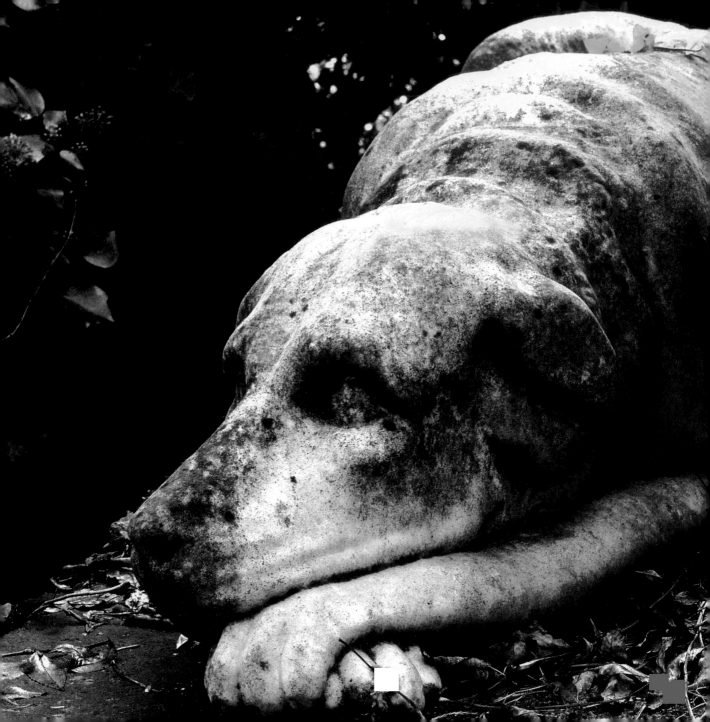

1 Thomas Sayers's tomb, Highgate Cemetery

Tom Sayers, the mid-nineteenth-century pugilist, was defeated only once in his lifetime. A bare-knuckle fighter – illegal at the time – he was the first boxer to be declared the World Heavyweight Champion. His dog, 'Lion', symbol of faith and devotion, waits patiently at the tomb.

2 Brown Dog, Battersea Park

Dogs can rouse strong emotions. This unheroic small bronze stands in memory of dogs used in vivisection experiments. The brown terrier in question was used in experiments at the Department of Physiology at University College, London in 1903. The National Anti-Vivisection Society, spurred by a group of Swedish activists who had infiltrated the department, claimed the experiments were cruel, alleging that the dog had been conscious and struggling. William Bayliss and his team, who performed the procedures, insisted that the animal had been properly anaesthetized. The resulting rumpus raged for seven years and split the country. It prompted the establishment of a commission to investigate the use of animals in experiments.

The original statue, which stood on top of a fountain with a trough for dogs, bore the inscription: *In Memory of the Brown Terrier Dog done to Death in the Laboratories of University College, London… Men and women of England, how long shall these things be?* This so angered pro-vivisectionists that the statue was regularly vandalized and needed constant police protection against the 'anti-doggers'. In March 1910, at dead of night, a long-suffering Battersea Council sent four workers accompanied by 120 police officers to remove it.

This replacement was erected in 1985. Bayliss is today credited with the discovery of a hormone, thanks to his research on dogs.

3 The Bulldog sign, Temple Place

The founder of the Bulldog Trust, Richard Hoare, chose its emblem as a mark of respect and admiration for Winston Churchill. It was set up in 1983 to generate support for selected charities.

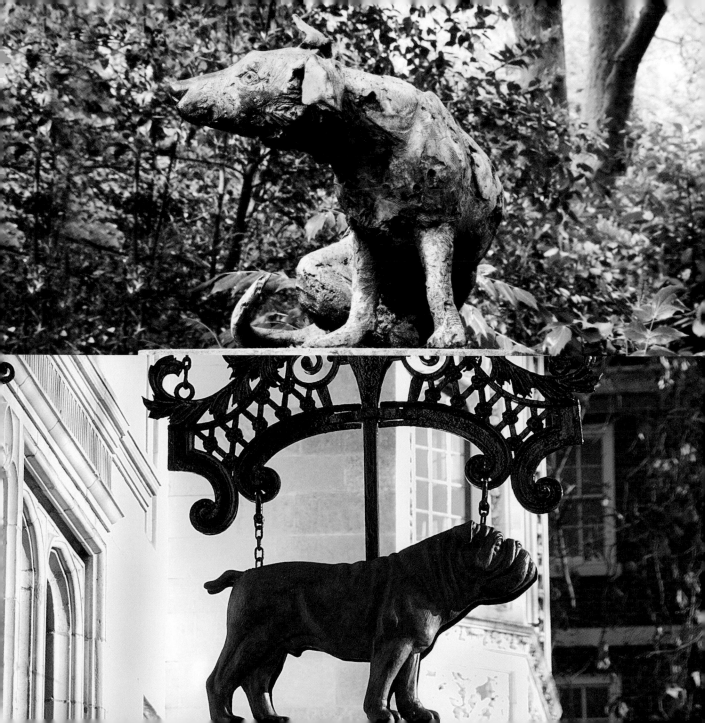

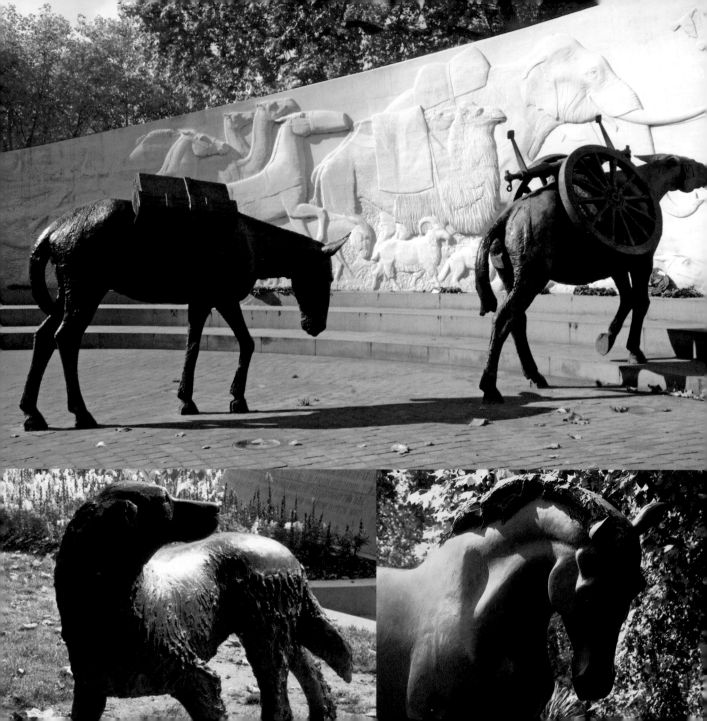

4 The Animals in War Memorial, Park Lane

This is a memorial to the millions of animals who died in twentieth-century wars. Situated in Park Lane and unveiled in 2004, it was designed by sculptor David Blackhouse and shows mules, horses, dogs, elephants, camels and pigeons. 'They had no choice' is carved into the curved Portland stone wall.

5 Dog and horse at the Animals in War Memorial, Park Lane

The bronzes of the happy-looking retriever and proud horse are on the north side of the curved stone wall – and are clearly looking to a brighter future. Both animals played a significant role in the world wars. Dogs were particularly effective in mine-detection (a Russian dog, Zucha, found 2,000 in eighteen days), and sniffing out potential survivors. They also laid telegraph lines with reels on their backs and carried messages.

Used throughout the history of warfare, eight million horses died in the First World War alone.

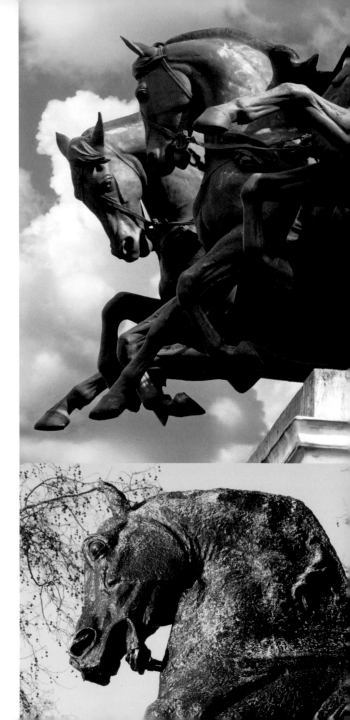

6 **The Quadriga, Hyde Park Corner**

Known as the Quadriga (a two-wheeled chariot drawn by four horses), this fine bronze group crowns the Wellington Arch at Hyde Park Corner. It represents 'Peace Descending on the Quadriga of War' and was sculpted by Adrian Jones in 1912.

7 **'Physical Energy', Kensington Gardens**
8 **'Rebellion', East India House**

G. F. Watts's and Judy Boyt's sculptures, from 1908 and 1993 respectively, demonstrate the appeal of the horse as an emblem of strength and nobility. Watts's vast bronze was originally intended to honour Muhammad, Attila, Tamerlane and Genghis Khan, thought by the artist to epitomise the raw will to power.

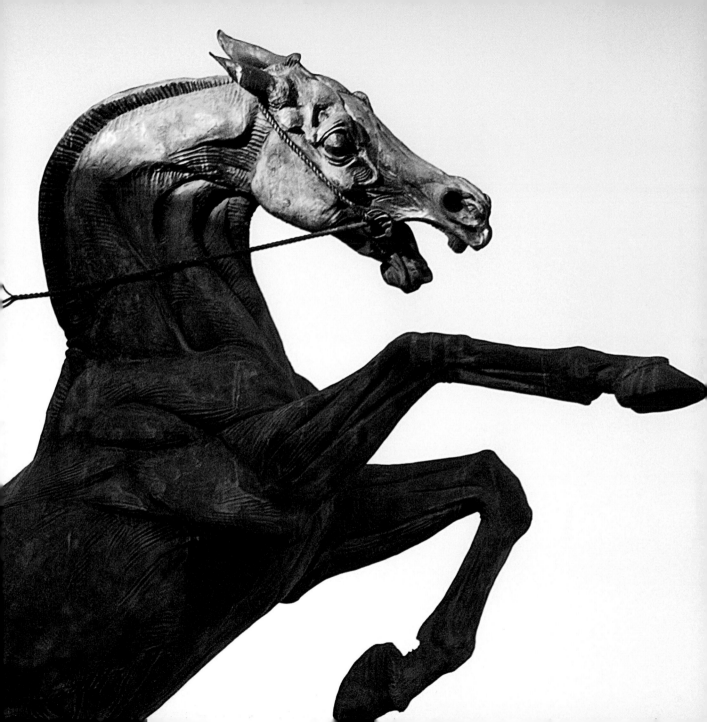

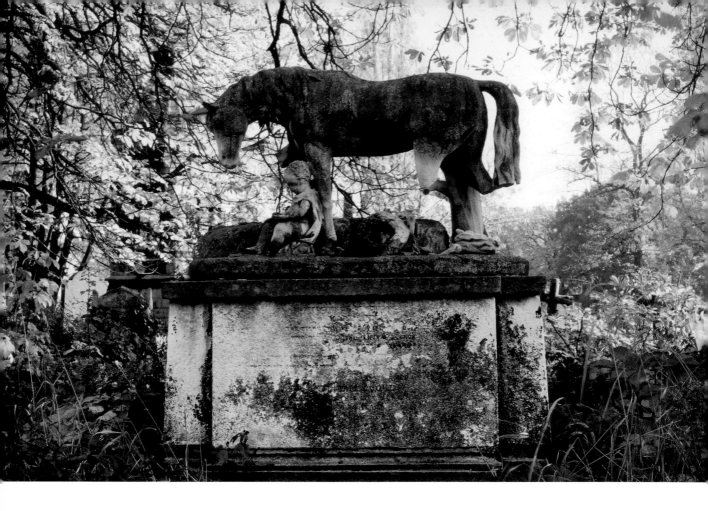

9 **William Cooke's tomb, Kensal Green Cemetery**

William Cooke (1807–86) advertised his 'Royal Circus' for the people of Greenock in Scotland, featuring his actor son Alfred. Standing on his horse, Alfred circled the ring at a slow canter portraying, with each round, a different Shakespearean character. He ended up as Richard III, shouting out his desire to exchange his kingdom for a horse.

10 Free-standing dray horse, Putney

He stands above the Spotted Horse pub, to which he
gives his name.

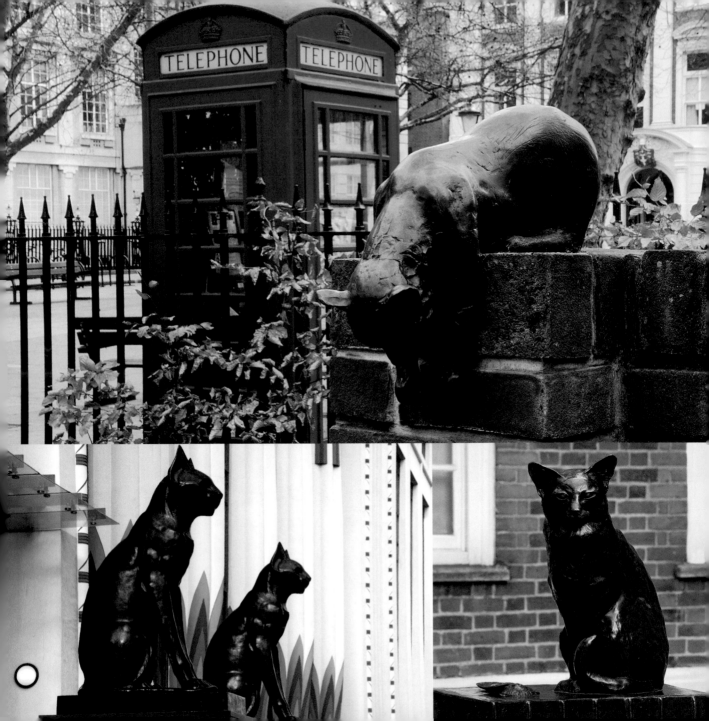

11 Sam, Queen Square, Camden

A memorial to Patricia Penn (1914–92), a local resident, and Sam, her beloved cat. London, with its labyrinth of garden walls behind residential terraces, is one of the most cat-friendly cities on earth – ideal for prowling and nocturnal flirtations. Famous felines, from T. S. Eliot's Macavity to Posy Simmonds' Fred, brought London's cats to world attention, making them into superstars.

12 Bronze cats, Mornington Crescent

Two huge black cats guard the entrance to Greater London House in Mornington Crescent – originally the site of the Carreras cigarette factory producing the famous 'Black Cat' brand.

13 Hodge the Cat, Gough Square

Hodge was Samuel Johnson's favourite cat – immortalized in Boswell's *Life of Johnson*. 'I never shall forget the indulgence with which he treated Hodge his cat: for whom he himself used to go out and buy oysters, lest the servants having that trouble should take a dislike to the poor creature.'

This small bronze statue (with two oysters) sits on a copy of Johnson's famous dictionary, with the inscription 'a very fine cat indeed'. It was erected in 1997 in the courtyard outside Dr Johnson's house in Gough Square, EC4.

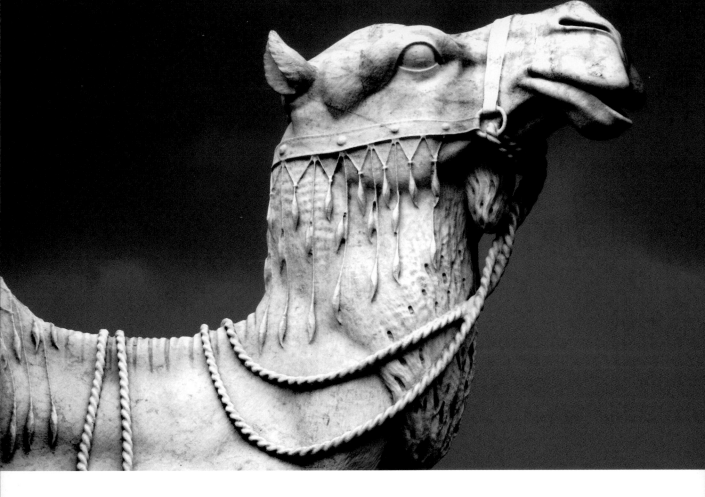

14 Camel on the Albert Memorial, Kensington Gardens

A detail from one of the four marble groups representing the four corners of the British Empire. The camel (sculpted by William Theed the Younger in 1872) symbolizes Africa. Asia is represented by an elephant, the Americas by a buffalo and Europe by a bull.

15 Elephant on the Albert Memorial, Kensington Gardens

The legacy of Empire can be seen in many representations of camels and elephants – and the Albert Memorial designed by George Gilbert Scott is a fine example.

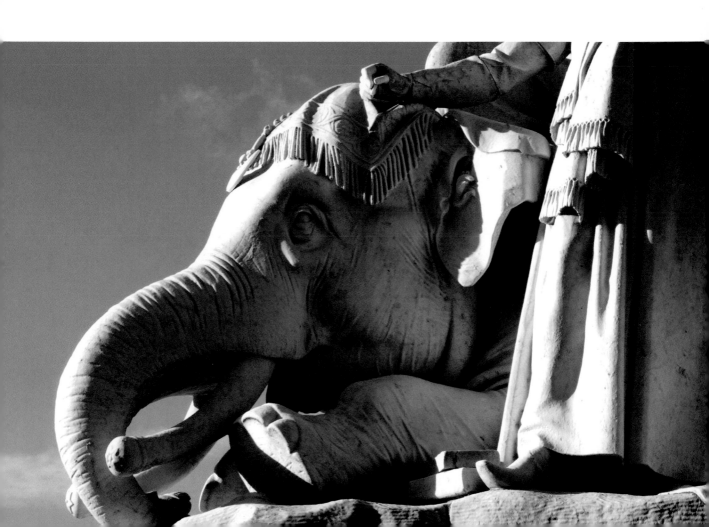

16 Camel seats along the Victoria Embankment

Camels played a role both in war and as beasts of burden. This is one of the cast-iron camel benches originally designed in the 1870s along the Victoria Embankment, showing the animal in the latter capacity.

17 Bronze memorial to the Imperial Camel Corps, Victoria Embankment Gardens

The north inscription reads: 'To the glorious and immortal memory of the officers, British/Australian/New Zealand and Indian who fell in action or died of wounds and disease in Egypt, Sinai and Palestine 1916–1918.' The south side lists the engagements.

18 Camel emblem, India House, Aldwych

There are several painted emblems adorning the exterior of India House, each one symbolizing a different province. This one represents Baluchistan.

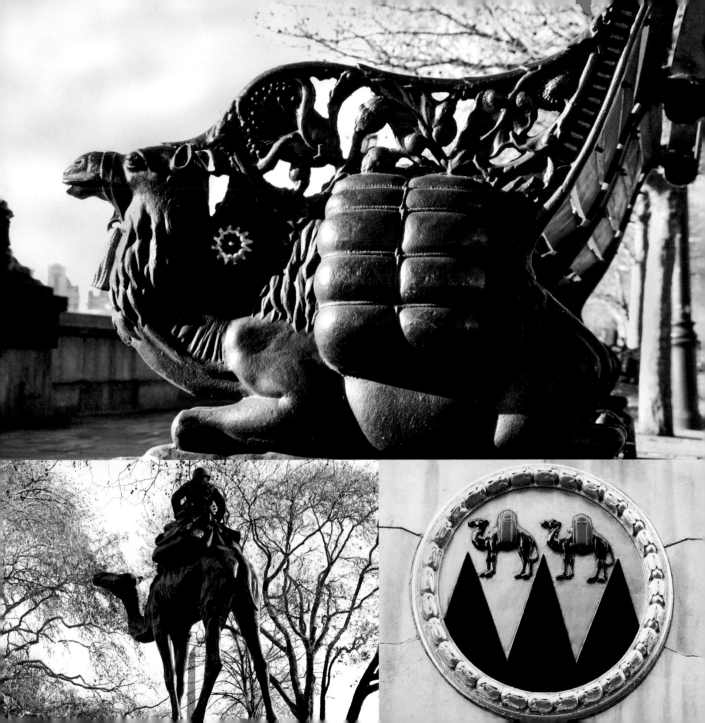

19 Bas-relief of camel train, Eastcheap

These camels sculpted in 1884 by William Theed the Younger (sculptor of the camel on the Albert Memorial) are the trademark of Peek Brothers, dealers in tea, coffee and spices. The camels, each with a differently shaped load, probably represent the three varieties of merchandise imported by Peek Brothers.

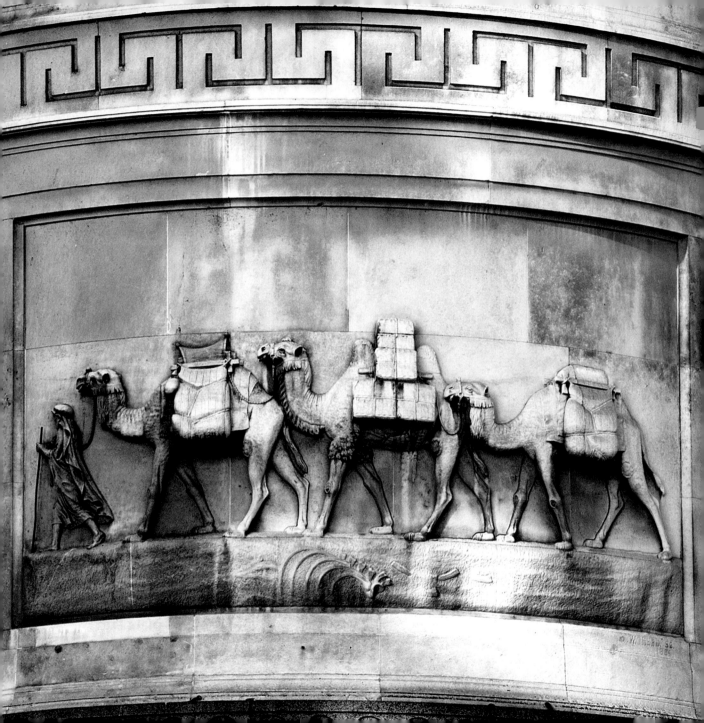

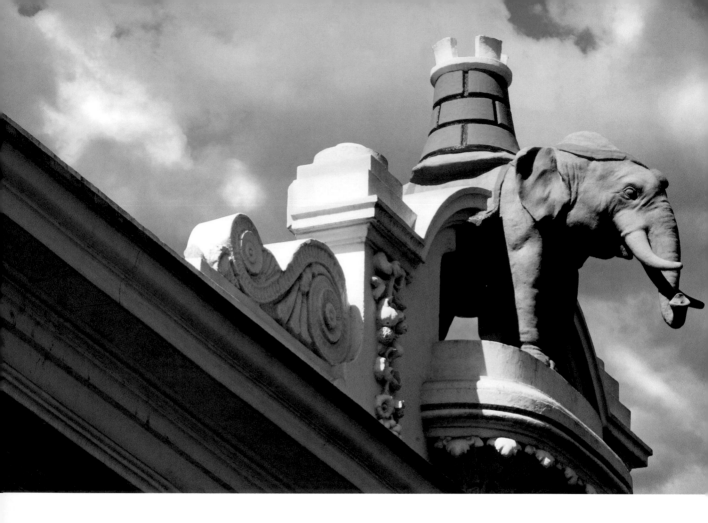

20 The Elephant and Castle statue, Vauxhall Cross

One of two similar statues high above the cornice of the former Elephant and Castle pub in Vauxhall. Some say the name is a corruption of 'la Infanta de Castilla', which probably refers to Eleanor of Castile (1241–90) who was the first queen consort of Edward I of England, but medieval bestiaries refer to Persians and Indians who used elephants as armoured vehicles, placing towers on their backs.

21 Salvador Dali's elephant with pyramid, South Bank

This bizarre sculpture with its spindly legs strikes a geometrical pose outside County Hall, opposite Big Ben.

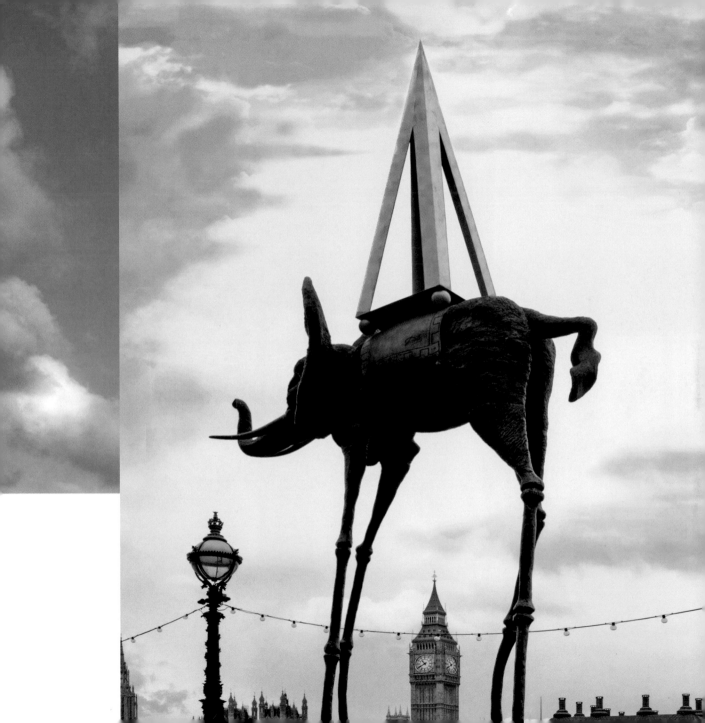

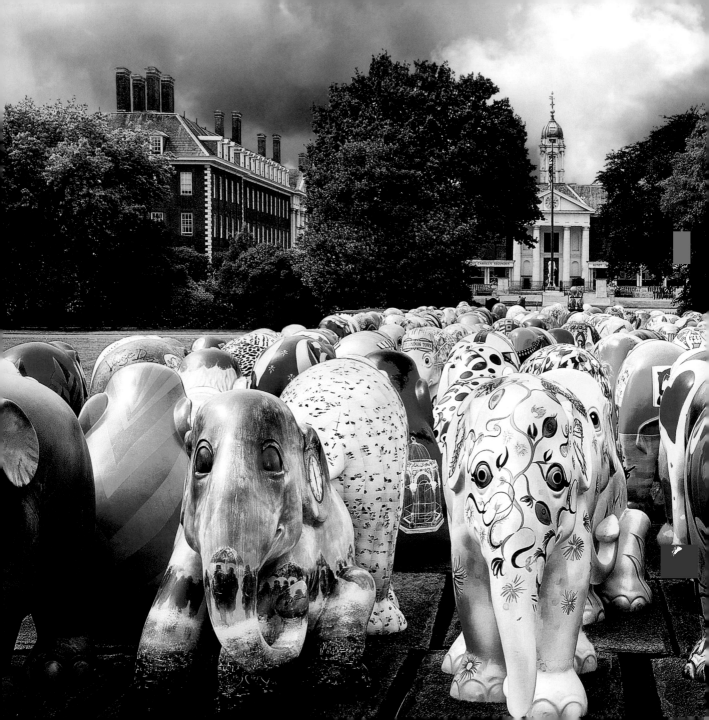

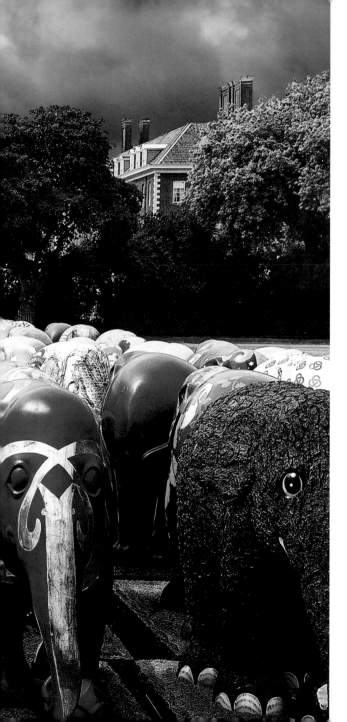

22 Elephants in Ranelagh Gardens, Chelsea Embankment

These elephants amassed in front of the Royal Chelsea Hospital in July 2010 were being cleaned prior to their auction at Sotheby's to raise money for the protection of Asian elephants and their habitat. Each one of the 260 animals was painted by a different contemporary artist.

23 Graffiti rat, Chiswell Street

While not exactly faithful and obedient, the rats painted by elusive graffiti artist Banksy tend to elicit a wry smile. Politically savvy, they often carry placards bearing witty comments about contemporary issues. This one originally said 'London Doesn't Work', but a rival artist called Robbo amended it to its present form.

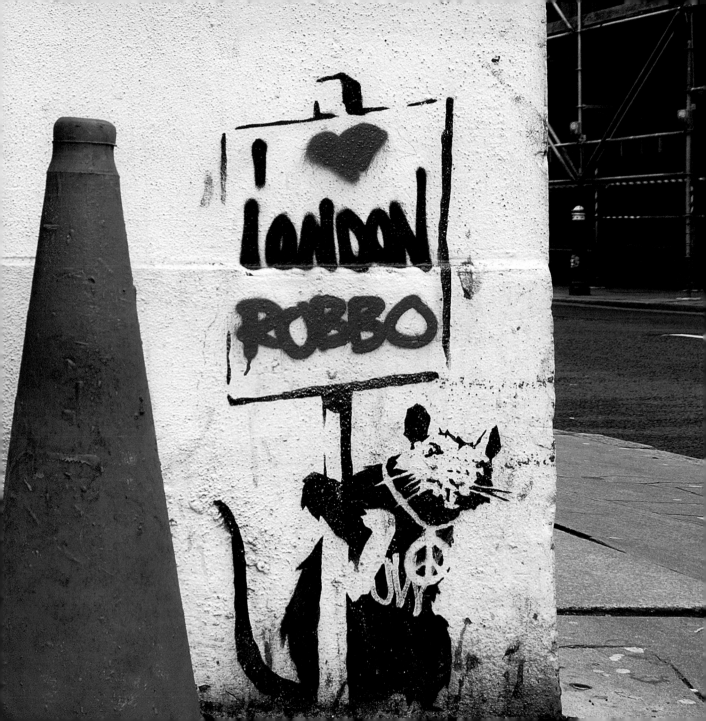

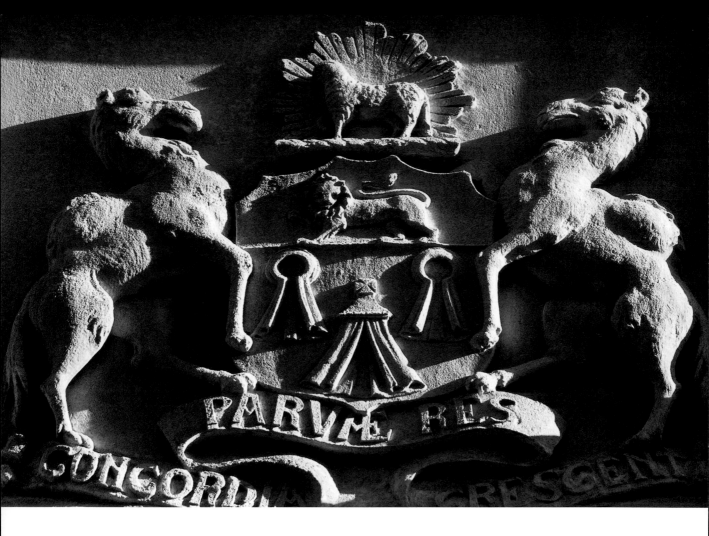

24 Coat of arms, near Charterhouse Square

This coat of arms belongs to one of the twelve Great Livery Companies, the Merchant Taylors. Its motto is *Concordia Parvae Res Crescunt* from the Roman historian Sallust, meaning 'In Harmony Small Things Grow'.

25 Elephant, Allington House, Victoria Street

This elephant, made by Barry Baldwin in 1997, lives over the doorway of Allington House.

26 Pet cemetery, Hyde Park

The first burial here was in the 1880s – for Cherry, the pet terrier of one Mr Bernard and his wife. When the Duke of Cambridge, commander-in-chief of the army, buried his wife's dog, Prince, he started a fashion that lasted until space ran out in 1915 after some 300 burials.

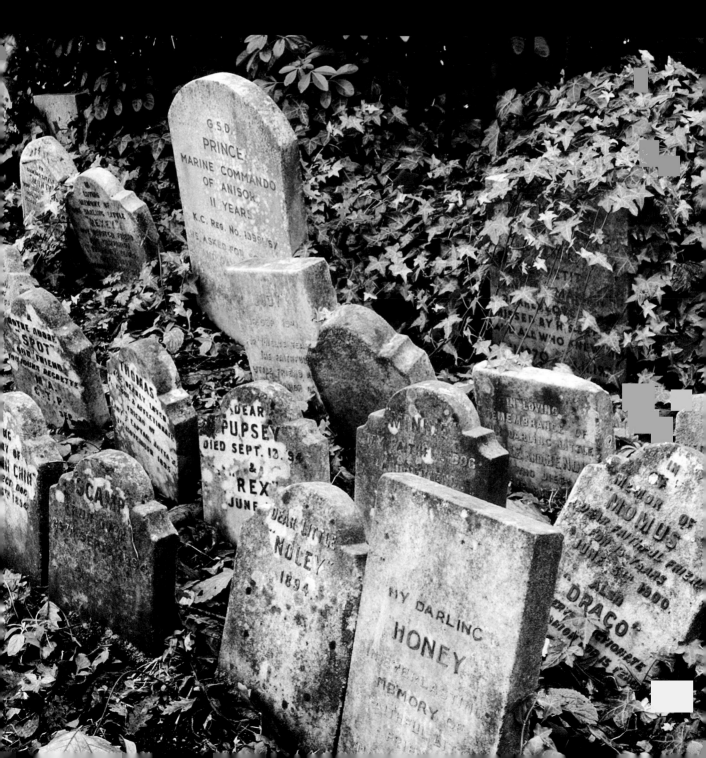

1 Victoria Embankment, WC2
2 Strand, WC2
3 Leadenhall Market, Gracechurch Street, EC3
4 St Mary-le-Bow, Cheapside, EC2
5 Horse Guards Parade, SW1
6 Durning Library, 167 Kennington Lane, SE11
7 Pont Street, SW1
8 Baglioni Hotel, 60 Hyde Park Gate,
 Kensington, W8
9 St George the Martyr Church, Queen Square,
 Camden, WC2
10 St George the Martyr Church, Queen Square,
 Camden, WC2
11 Holborn Viaduct, EC1
12 Westway, W12
13 41 Lothbury, EC2
14 Southwark Cathedral, Montague Close, SE1
15 Milestone Hotel, 1 Kensington Court, W8
16 Inner Temple, EC4
17 Limehouse, E14
18 Kew Gardens, Richmond, TW9
19 Chiswick House, Burlington Lane, Hounslow, W4
20 Buckingham Palace, SW1

Islington

Pentonville Road

City Road

Clerkenwell

Shoreditch

Bloomsbury

9+10

Stepney

11

13

2

Soho

4

3

17

Covent
Garden

16

City of London

1

Aldgate

5

14

Waterloo

Southwark

Rotherhithe

City of
Westminster

6

mlico

Lambeth

Vauxhall

Mythological and Hybrid Creatures

MAP CHAPTER 3

Stockwell

Mythological and Hybrid Creatures

If you look closely whilst wandering in the heart of London, you cannot help but be struck by the fierce silver beasts and predatory monsters perched atop stone plinths. They have upswept wings, their claws clutch the red cross of St George and their scarlet arrowhead tongues make their ferocity all the more alarming. These are the so-called 'boundary dragons' erected by the City of London Corporation to mark the main entrances to the City – known since medieval times as the Square Mile. Today they flank either side of Holborn, run along the Victoria Embankment, and guard the southern ends of London Bridge and Blackfriars Bridge. With the head and wings of an eagle – king of the skies – and the body of a lion – king of the beasts – they are, in fact, griffins, by far the most popular mythical hybrid. This powerful creature is all-seeing, majestic and fearsome, an inspirational icon for the traders and bankers who operate one of the world's great financial centres. And naturally, the winged lions derived from the same ancient ancestors as the griffin are almost as popular.

Make-believe creatures originating in mythology and folklore, with their heraldic resonances and protective powers, appeal not only to public bodies but also wealthy individuals. As well as dragons and griffins we find hippocamps, sphinxes and unicorns, not to mention Pegasus. The continued appeal of made-up monsters is shown by Mechanosaurus: a Jurassic reptile constructed by a gifted, unnamed artist working in a car breakers' yard.

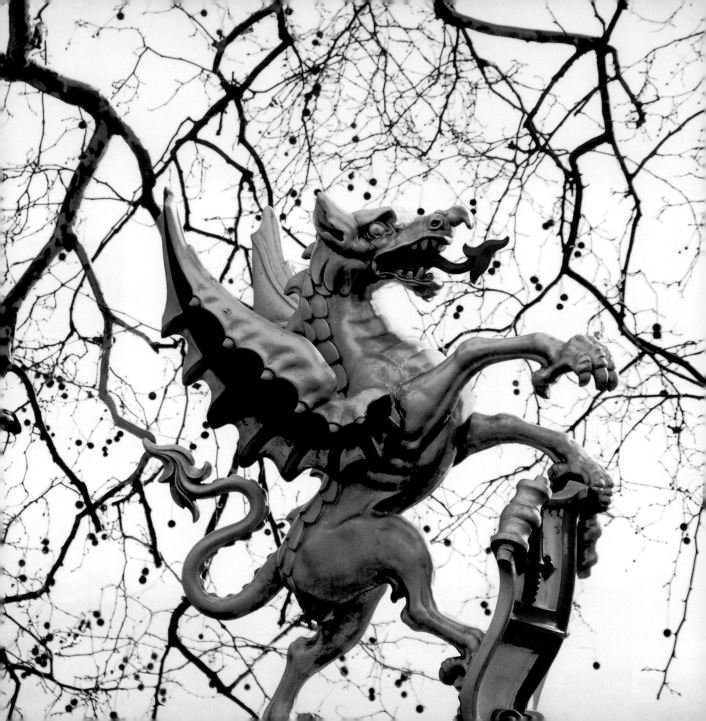

1 **Boundary dragon, Victoria Embankment**

This dragon, with several others, was removed from the Coal Exchange Building in Lower Thames Street when it was demolished in 1963. The idea of marking the City boundaries with dragons came from the London Streets Committee. They are the official emblem for the City of London Corporation.

2 Temple Bar boundary statue, Strand
Sculpted by Charles Bell Birch, this heraldic griffin looming above the Temple Bar Memorial (1880), with the Royal Courts of Justice in the background, marks the western limit of the City of London. It was the site of the most celebrated gateway to the City where traditionally the monarch was met and welcomed by the Lord Mayor.

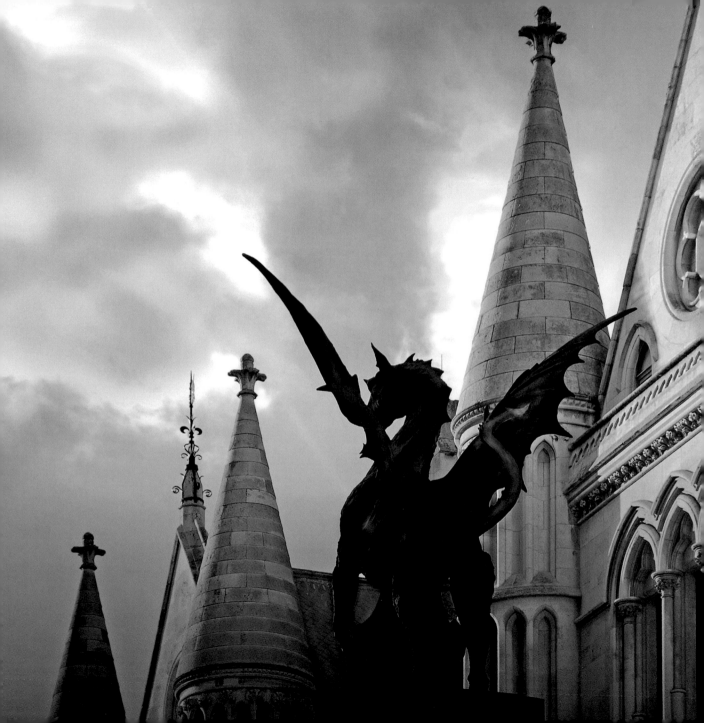

3 Griffin, Leadenhall Market

This heraldic griffin is one of several designed for the market by Sir Horace Jones in 1880. Leadenhall stands on the centre of what was Roman London, and there has been a market here since the fourteenth century. Originally specializing in meat, game and poultry, you can nowadays purchase just about anything you want in Leadenhall, including exotic meats, savoury biscuits and cheeses. Jones was also the architect of Billingsgate and Smithfield markets.

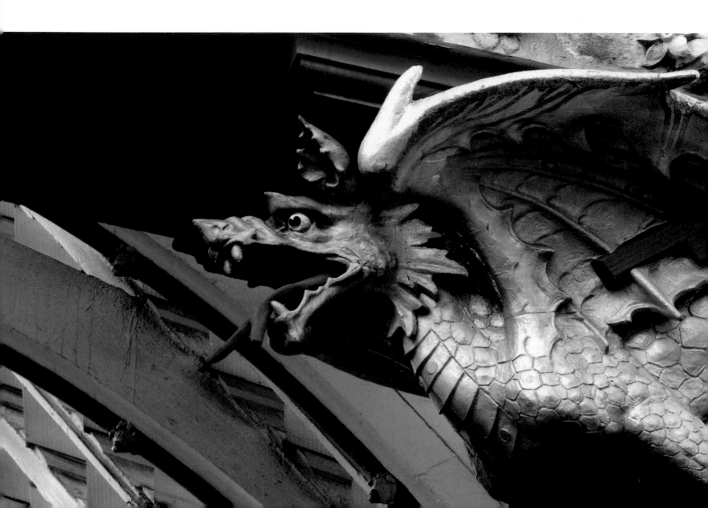

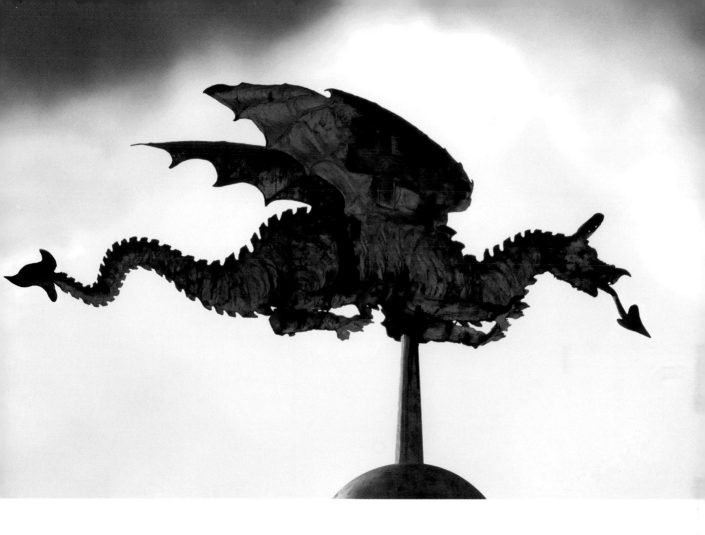

4 **Dragon weathervane, St Mary-le-Bow, Cheapside**

This was one of the first churches to be rebuilt after the Great Fire of London in 1666. Robert Bird made the spire for Wren's church in 1679. Unlike the so-called boundary dragons (which are really griffins), this gilded one belongs to the authentic, Welsh variety – a scaly winged crocodile with a serpent's tail. All dragons are supposed to breathe fire.

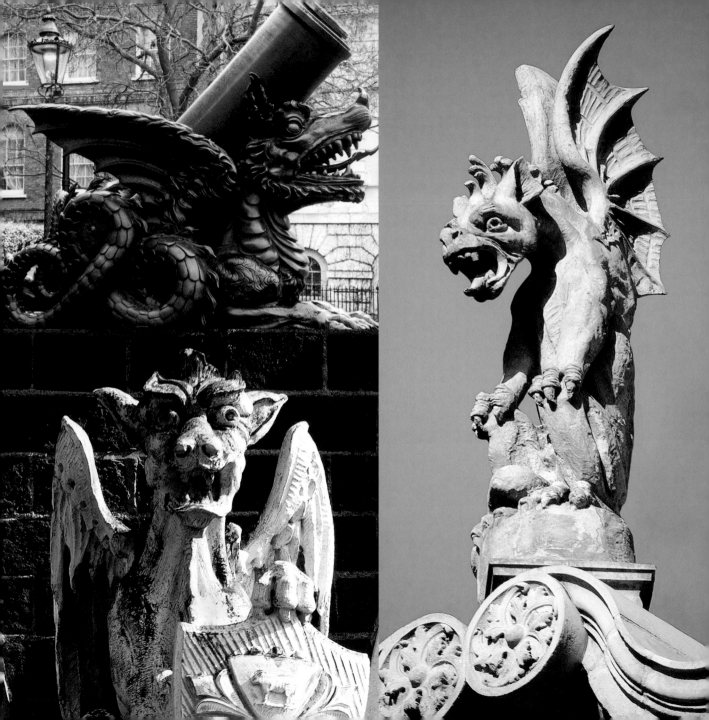

5 Cadiz Memorial, Horse Guards Parade

This aggressive concoction consisting of a French mortar mounted on a cast-iron Chinese dragon was a gift from the Spanish Government to the Prince Regent. It celebrates the lifting of the siege of Cadiz following the defeat of the French forces near Salamanca in July 1812 by the Duke of Wellington's army.

6 Griffin on Durning Library, Kennington Lane

This bulging-eyed monster gazing from the library's richly embellished late-Victorian facade is hardly welcoming to readers.

7 Terracotta griffin, Pont Street

There are many such Gothick-inspired figures decorating the rooftops of late-Victorian mansion blocks in London. Some of them are hard to see because they are so high up.

8 **Winged lion on the corner of De Vere Gardens and Kensington Road**

This building, now a hotel, boasts four proud lions above decorated capitals and spiral fluted pillars – one for each corner. Winged lions sometimes acted as brackets to canopied Queen Anne doorways, enhancing the sense of awe expected from visitors.

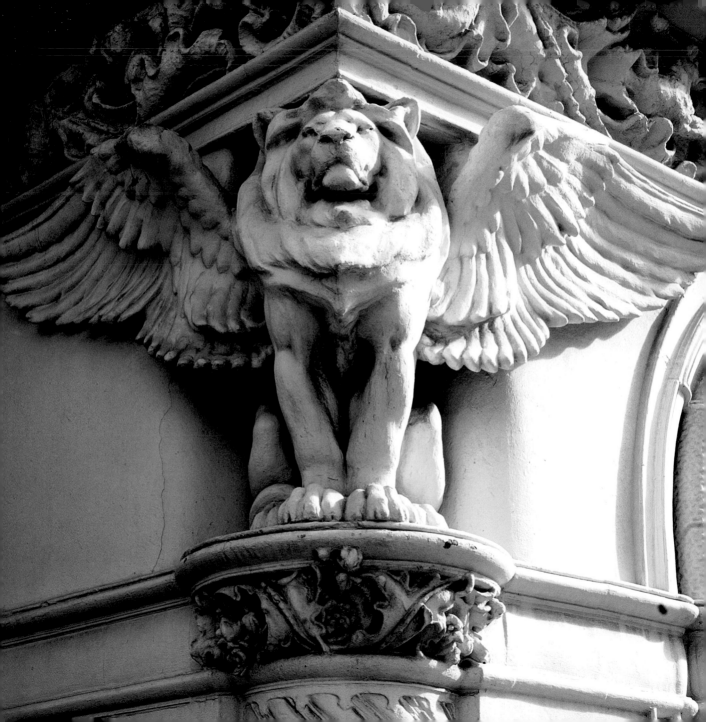

9 Lion symbol of St Mark, St George the Martyr Church, Queen Square, Camden

One of four plaster roundels on the east side of the church, representing the evangelists. In the Book of Revelation the description of the four winged creatures round the throne of God – a lion, an ox, a man and an eagle – came to symbolize the four Gospel-writers, Mark, Luke, Matthew and John.

10 Ox symbol of St Luke, St George the Martyr Church, Queen Square, Camden

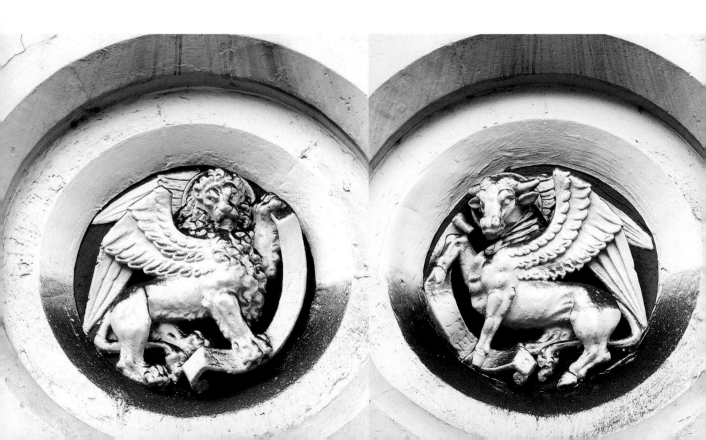

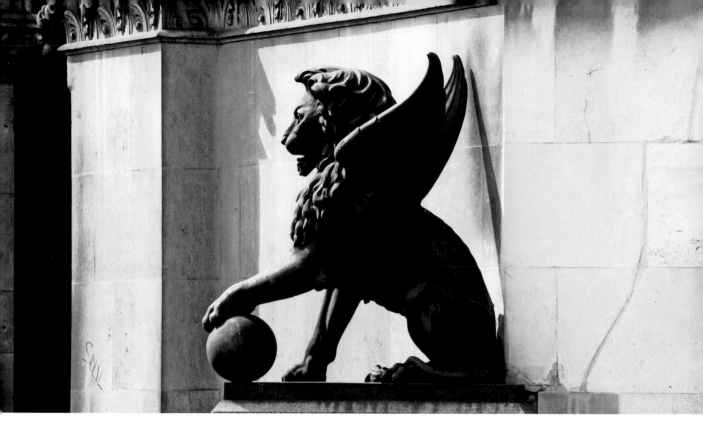

11 Bronze lion guarding Holborn Viaduct

The four winged lions at the ends of the viaduct, each with its left paw resting on a small globe, were made by Farmer and Brindley in 1869. The viaduct was built between 1863 and 1869 and passes over Farringdon Street and the now subterranean River Fleet. It was opened by Queen Victoria at the same time as Blackfriars Bridge.

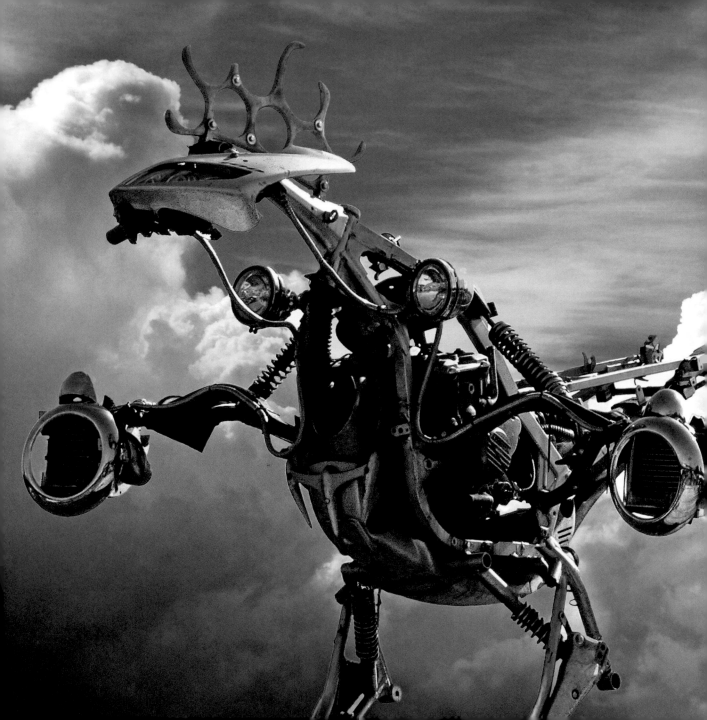

12 'Mechanosaurus', Westway

Created by an unknown artist in a car breakers' yard by the Westway flyover, this sculpture is made from the discarded parts of cars and motorbikes.

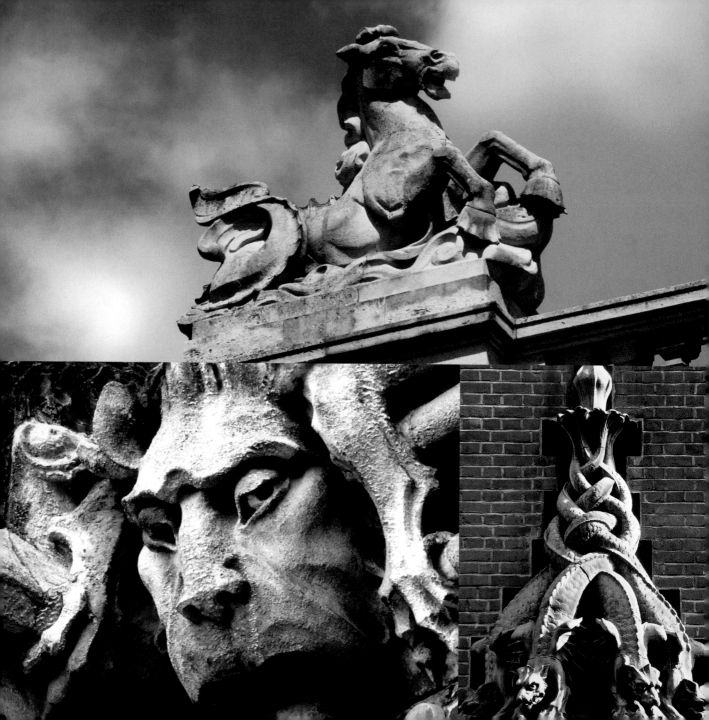

13 Hippocamp, 41 Lothbury

One of two stone hippocamps high upon the roof of 41 Lothbury, former headquarters of the National Westminster Bank. A hippocamp is a Greek mythological creature with the front of a horse and coiling, fishlike hindquarters not unlike a sea horse, from which it may have derived.

14 Medieval gargoyle, Southwark Cathedral

As an exercise in ghoulishness this is hard to beat. The function of gargoyles is to stop rainwater running down the sides of buildings so they invariably have wide open mouths through which the water can spew. The word is derived from the French *gargouille* meaning 'throat'. They are said to scare off evil or harmful spirits.

15 Entwined sea monsters (or dragons), Milestone Hotel, Kensington

This fearsome statue sits incongruously on the west side of the Milestone Hotel, originally designed as a private residence in 1885. It is indebted to the Victorian fashion for fifteenth- and sixteenth-century Flemish architecture and was inspired by the spiral design on the Exchange Building in Copenhagen.

16 Roundel of Pegasus, Inner Temple

It is a mystery why Pegasus, the Greek mythological winged horse born of Poseidon and the gorgon Medusa, should have become the emblem of the Inner Temple's coat of arms, here shown decorating its iron gates. The answer may lie in some old tiles in the Temple Church depicting a Knight Templar on horseback with a raised sword and shield – suggesting wings. In medieval and Renaissance times Pegasus was also considered a symbol of wisdom.

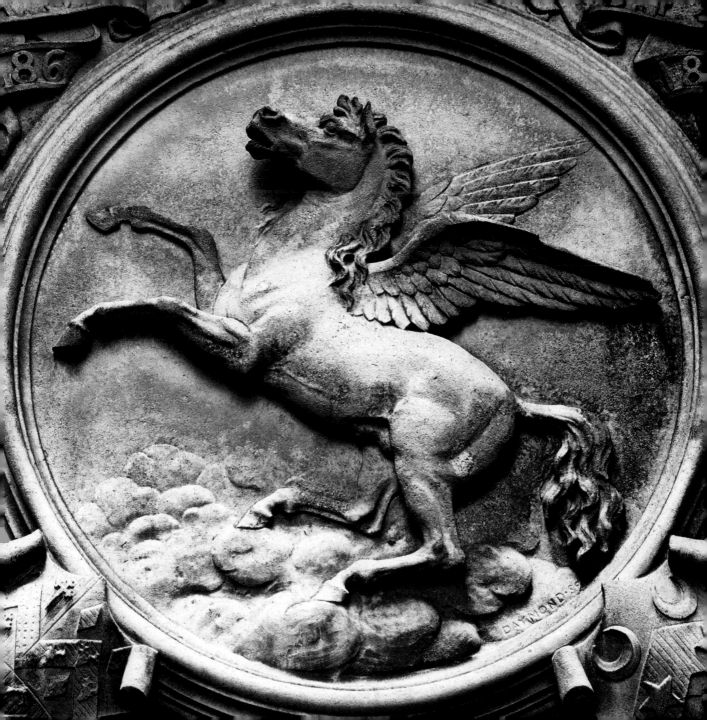

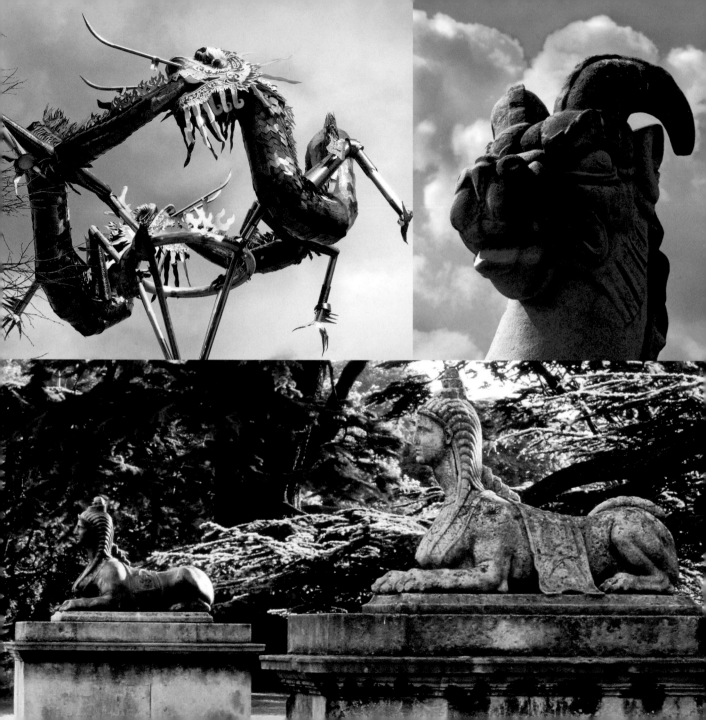

17 Chinese dragons, Limehouse

This Chinese dragon sculpture marks the centre of the former Chinese settlement in Limehouse, created in the late nineteenth century.

18 The yale of Beaufort statue, Kew Gardens

Carved in Portland stone by James Woodford in 1956 and standing outside the Palm House, this is one of the ten heraldic beasts depicting the genealogy of Elizabeth II. The yale was a mythical ungulate who was able to swivel each of its horns independently. It descends to the Queen through Henry VII, who inherited it from his mother, Lady Margaret Beaufort.

19 Sphinxes, Chiswick House, Hounslow

There are, in all, six sphinxes in the grounds of the magnificent Neo-Palladian villa designed by Lord Burlington in the 1720s. As custodians of arcane and occult knowledge, they were probably intended as symbolic guardians of the villa estate.

20 **Detail of the unicorn on the gates of Buckingham Palace**

The unicorn is the only fabulous beast that does not seem to have been conceived out of human fears. He is described in the Bodlean's *Bestiary* as being fleet of foot, and can only be caught in the following fashion: 'A girl who is a virgin is led to the place where it dwells, and is left there alone in the forest. As soon as the unicorn sees her it leaps into her lap and embraces her, and goes to sleep there; then the hunters capture it and display it in the king's palace.'

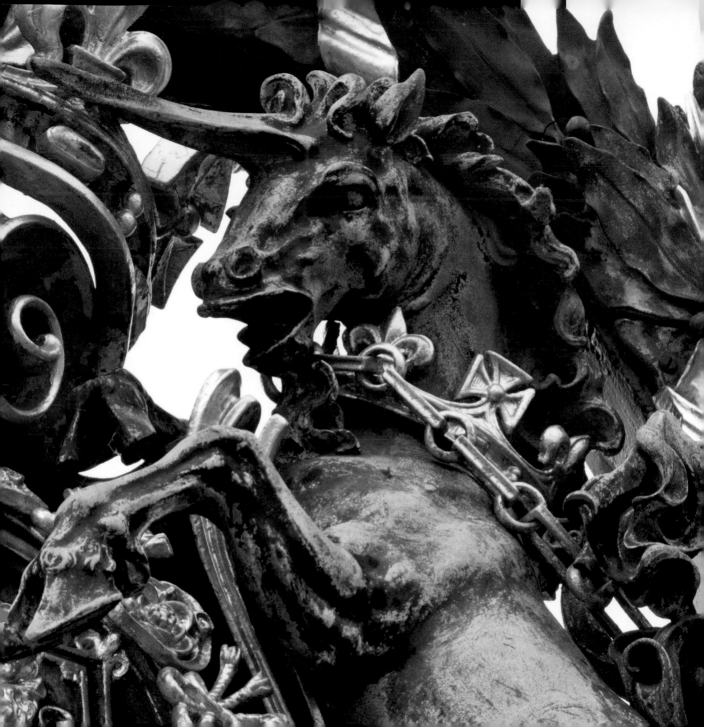

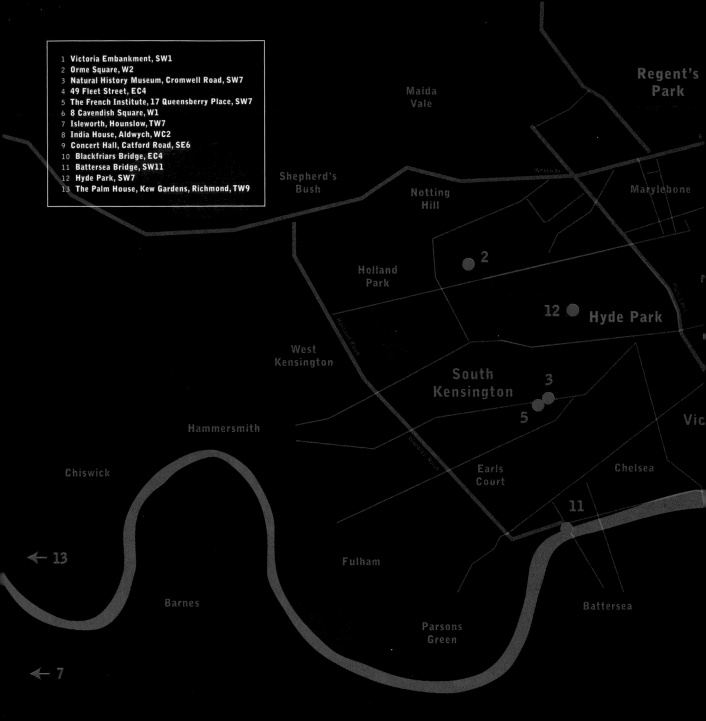

1 Victoria Embankment, SW1
2 Orme Square, W2
3 Natural History Museum, Cromwell Road, SW7
4 49 Fleet Street, EC4
5 The French Institute, 17 Queensberry Place, SW7
6 8 Cavendish Square, W1
7 Isleworth, Hounslow, TW7
8 India House, Aldwych, WC2
9 Concert Hall, Catford Road, SE6
10 Blackfriars Bridge, EC4
11 Battersea Bridge, SW11
12 Hyde Park, SW7
13 The Palm House, Kew Gardens, Richmond, TW9

Regent's
Park

Maida
Vale

Westway

Marylebone

Shepherd's
Bush

Notting
Hill

Holland
Park

2

12 Hyde Park

West
Kensington

Holland Road

South
Kensington

3

5

Vic

Hammersmith

Warwick Road

Earls
Court

Chelsea

Chiswick

11

← 13

Fulham

Battersea

Barnes

Parsons
Green

← 7

Birds
of
Distinction

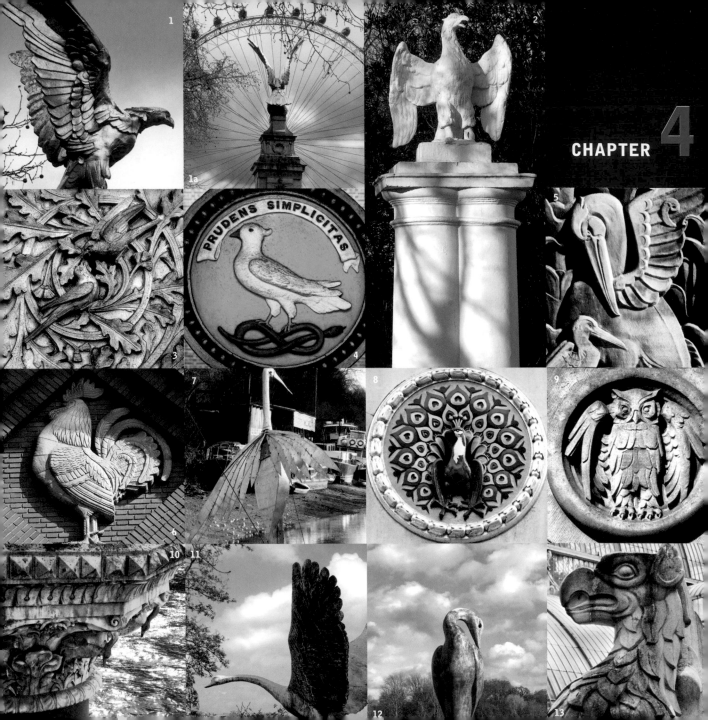

PRUDENS SIMPLICITAS

Birds
of
Distinction

Birds have always held a special place in the human psyche. The source of countless allegories and superstitions, their hold on our imaginations must have its origins in their ability to defy gravity and to surf the skies. Historically, they were seen as denizens of heaven or souls of the departed.

Just as lions rule the land, so eagles are kings of the sky. In ancient Persia the eagle was identified with the sun. Universally he symbolises majesty, strength, and swift alertness. Eagles are icons of the world's most powerful rulers, from the imperial sigil of the Roman Empire to the double-headed eagle of the Russian tsars. Its status remains supreme: today the eagle is not only a symbol of American power, but is on the coats of arms of no less than twenty-nine countries.

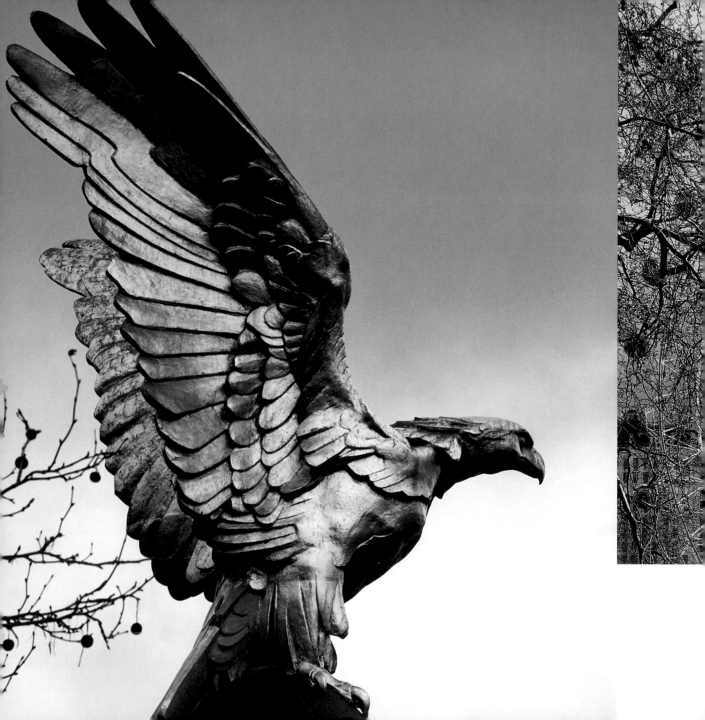

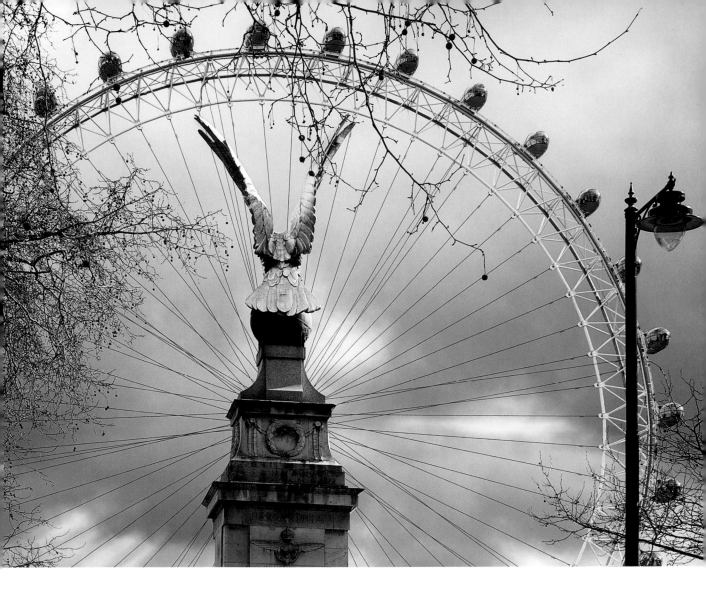

1 The Royal Air Force Memorial, Victoria Embankment

This memorial, with the London Eye in the background, was unveiled in 1923 to commemorate the casualties of the Royal Air Force in the First World War – and by extension all subsequent conflicts. The golden eagle was sculpted by William Reid Dick and symbolizes the indomitable spirit of the Air Force.

2 Eagle, Orme Square, Bayswater

This stone statue on its double-columned plinth was probably erected in the mid-nineteenth century to define the entrance to the square built by Edward Orme, who died in 1848.

3 Doves, Natural History Museum, South Kensington

This terracotta bas-relief was designed by Alfred Waterhouse in 1875–6. In Christian iconography the dove is a symbol of the Holy Ghost, and is frequently shown in images of Christ's baptism. It also symbolizes the release of the soul in death, and more generally represents purity, grace and unconditional love. Turtle doves are symbols of fidelity because of their reputation for lifelong devotion to their chosen mate.

4 Dove and serpent, Serjeant's Inn, Fleet Street

This painted roundel is on the gates of Serjeant's Inn, now owned by the Inner Temple. *Prudens Simplicitas* means 'Wise Simplicity'.

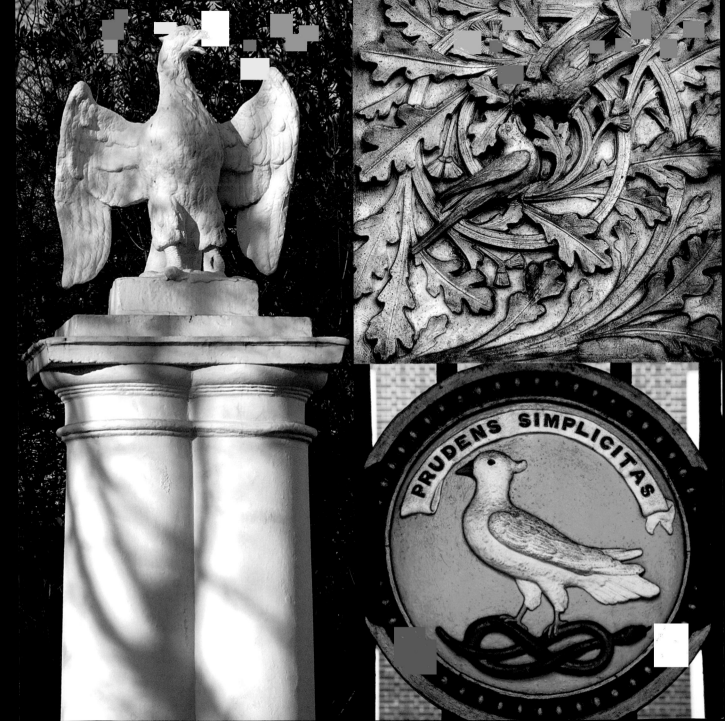

PRUDENS SIMPLICITAS

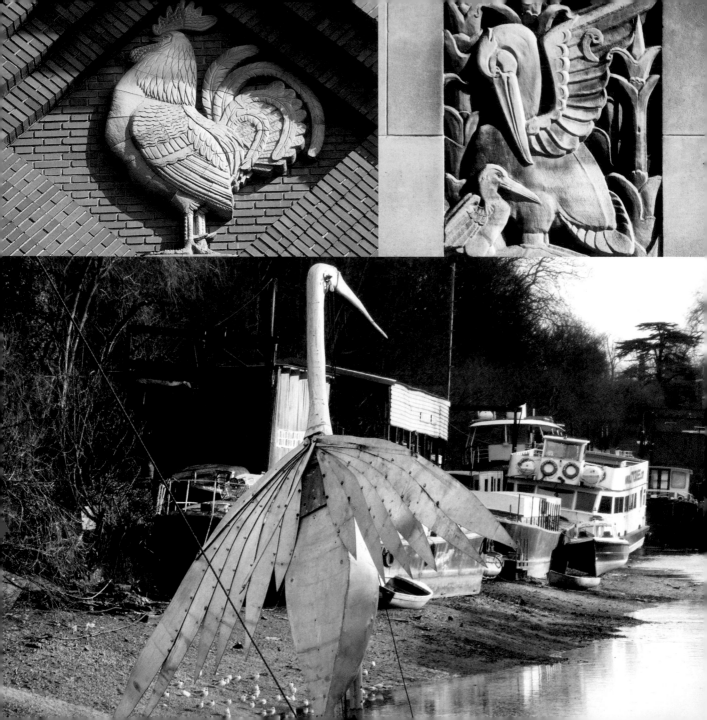

5 Cockerel, the French Institute, South Kensington

And what of the cockerel? Loved and abused in equal measure as a universal alarm clock, he plays a crucial role both in the New Testament – thereby earning his reputation as a symbol of vigilance – and as the emblem of French national culture. This latter may have arisen because the Latin words for 'rooster' (*Gallus*) and 'inhabitant of Gaul' (*Gallicus*) are similar. But although the cockerel was revered in France from at least the fourteenth century, Napoleon was not so keen. When a commission of Councillors of State proposed it as an emblem of France, the Emperor rejected it on the grounds that 'The cockerel has no strength; in no way can it stand as the image of an empire such as France.' So he replaced it with the inevitable eagle.

In the nineteenth century, however, it regained its popularity, featuring on military buttons on the Great Seal of France. Eventually the Gallic cockerel enjoyed so much popularity that during the First World War it was often represented as standing in opposition to the German imperial eagle. This is one of four ceramic plaques on the west front of the Institute.

6 Pelican with her young, 8 Cavendish Square

Because of a misinterpretation of her posture (probably first recorded in the *Physiologus* and passed on to the medieval bestiaries), the pelican was thought to stab her breast and provide her own blood to her young when no other food was available. As a result she became a symbol of the Passion of Christ, as well as a more general icon of self-sacrifice. This splendid bird has accrued eternal fame by simply being itself. This keystone relief is on the front of no. 8 Cavendish Square. Her living relatives still adorn the lake in nearby St James's Park.

7 Avian prow head, Isleworth

This heron-like bird on a Thames river boat keeps a lookout along the river.

8 Peacock emblem, India House, Aldwych

Though the peacock is synonymous with pride because of the male's exotic beauty, he is also identified with royalty, immortality and watchfulness – the latter due no doubt to the eye-shaped marks in his tail. In Greek mythology, Hera (Juno) set Argus's one hundred eyes into the tail of a peacock, her royal bird. The eyes symbolized the stars that watch all life unfolding on earth.

Here, the peacock represents Burma – a part of the Indian Empire during the British Raj.

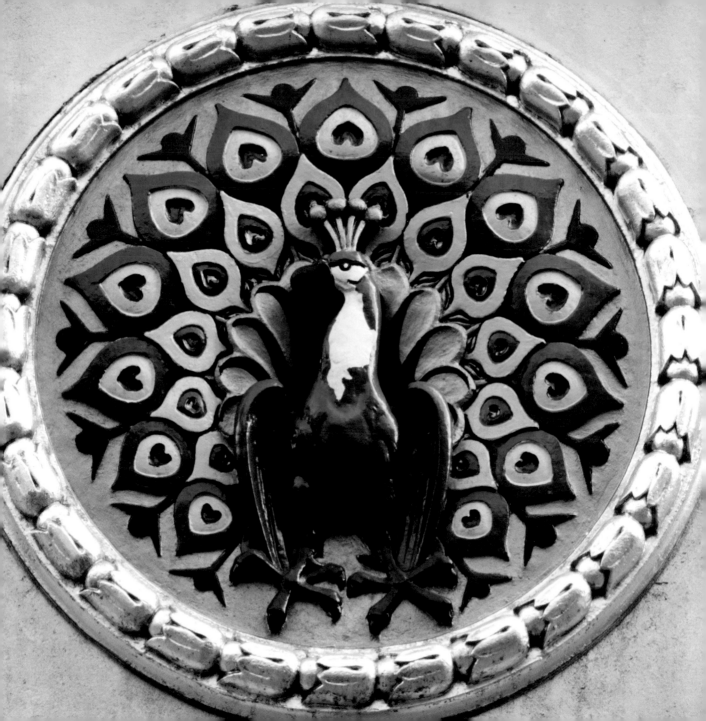

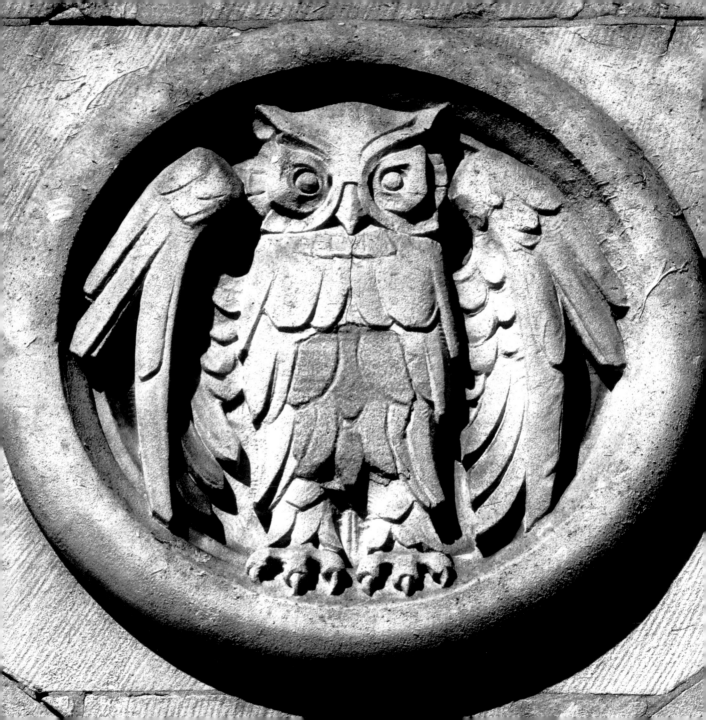

9 Carved stone roundel of an owl, Concert Hall, Catford

The symbolism of the owl, as one might expect from such a mysterious creature, is complex and contradictory. On the one hand his nocturnal lifestyle associates him with spirits, psychic powers and sometimes the angel of death. In this context he is connected to witchcraft and sorcery, and his furtiveness and otherworldly hoots and screeches merely add to this impression. On the other hand, in his ancient role as cohort of Athena, Greek goddess of wisdom, he is identified with wisdom, vigilance and patience.

10 **Carved swans, Blackfriars Bridge**

These capitals, from 1869, are by John Birnie Philip. Swans have a proven reputation for fidelity, which makes them popular with moralists. This is undermined, however, by the erotic symbolism of the famous story of Leda and the Swan, in which Zeus, disguised as a swan, seduced Leda, queen of Sparta, resulting in the birth of Helen of Troy.

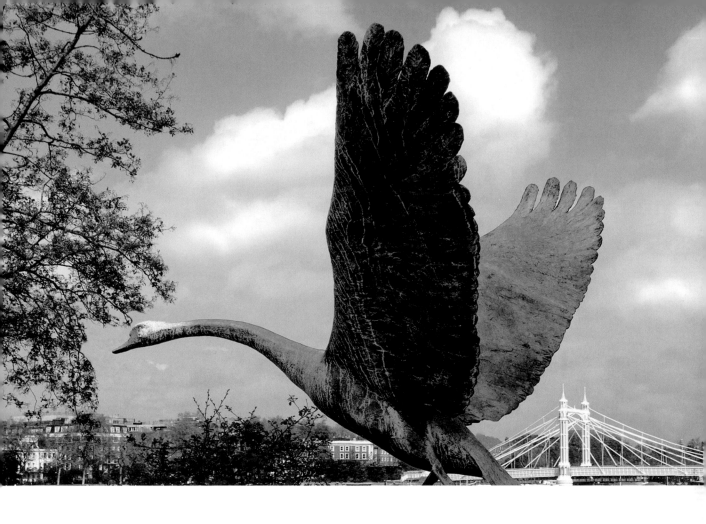

11 **Bronze swan on the Thames, with Albert Bridge in the background**

One of a pair, poised for take-off, sculpted by Catherine Marr-Johnson in 1984. Swans are ubiquitous in London, frequenting the Thames and parks. Considered a delicacy in medieval times, they were reserved for the royal table.

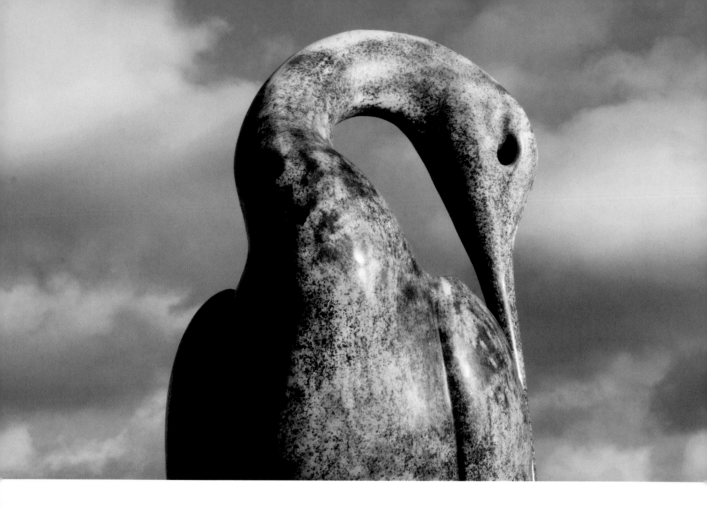

12 The statue of Isis, Hyde Park

This three-metre bronze statue of an ibis by the Serpentine in Hyde Park was sculpted by Simon Gudgeon. Unveiled in 2009, it has slots at its base to elicit contributions for an eco-friendly wildlife education centre near by. It is named after Isis, the Egyptian goddess of motherhood and nature, who took the form of an ibis.

13 Falcon statue in front of the Palm House, Kew Gardens, Richmond

This Portland stone sculpture is one of the 'Queen's Beasts', a group of ten heraldic creatures designed by James Woodford for her coronation in 1953. The falcon was the emblem of the Plantagenets, who ruled England from 1154 to 1485.

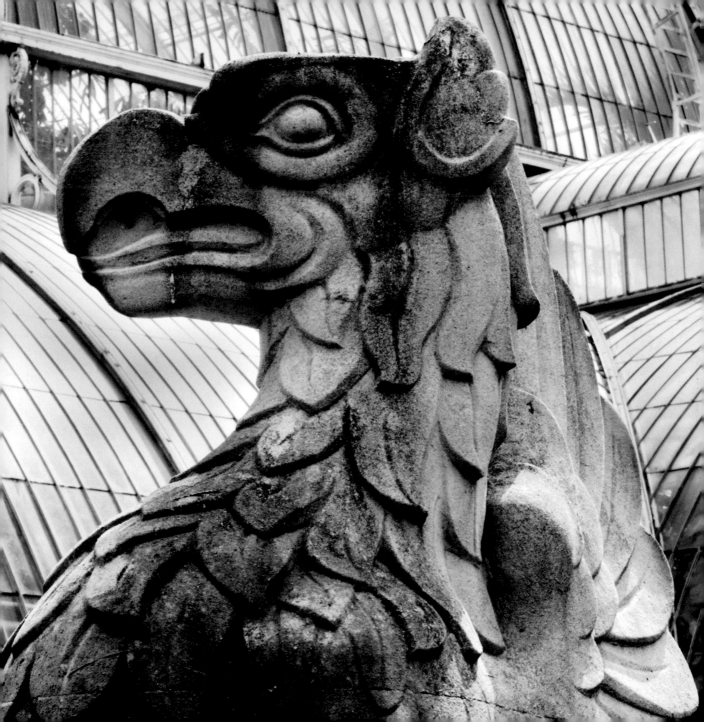

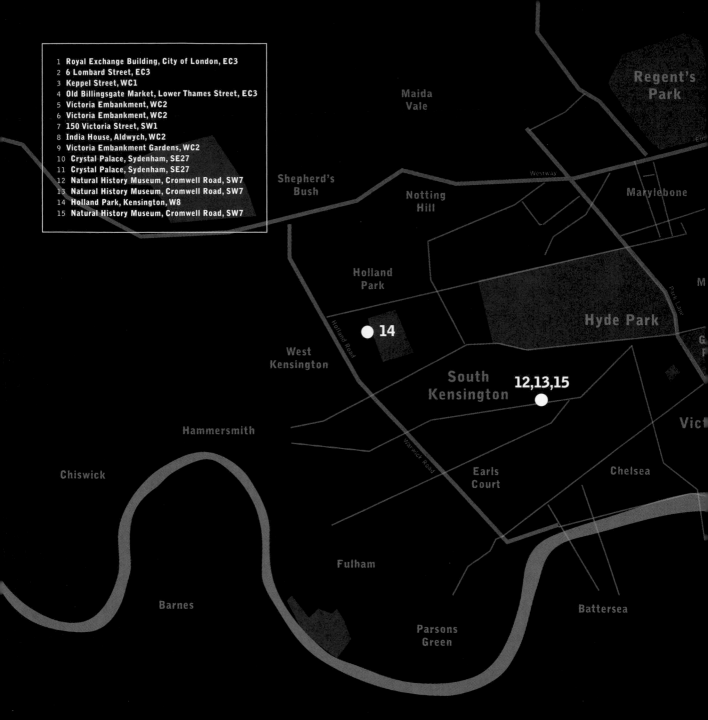

1 Royal Exchange Building, City of London, EC3
2 6 Lombard Street, EC3
3 Keppel Street, WC1
4 Old Billingsgate Market, Lower Thames Street, EC3
5 Victoria Embankment, WC2
6 Victoria Embankment, WC2
7 150 Victoria Street, SW1
8 India House, Aldwych, WC2
9 Victoria Embankment Gardens, WC2
10 Crystal Palace, Sydenham, SE27
11 Crystal Palace, Sydenham, SE27
12 Natural History Museum, Cromwell Road, SW7
13 Natural History Museum, Cromwell Road, SW7
14 Holland Park, Kensington, W8
15 Natural History Museum, Cromwell Road, SW7

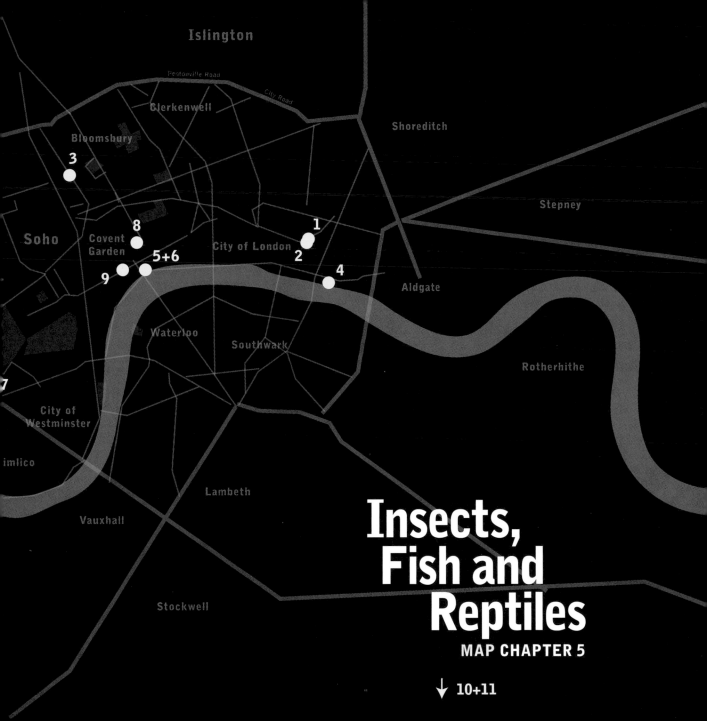

Insects,
Fish and
Reptiles
MAP CHAPTER 5

↓ 10+11

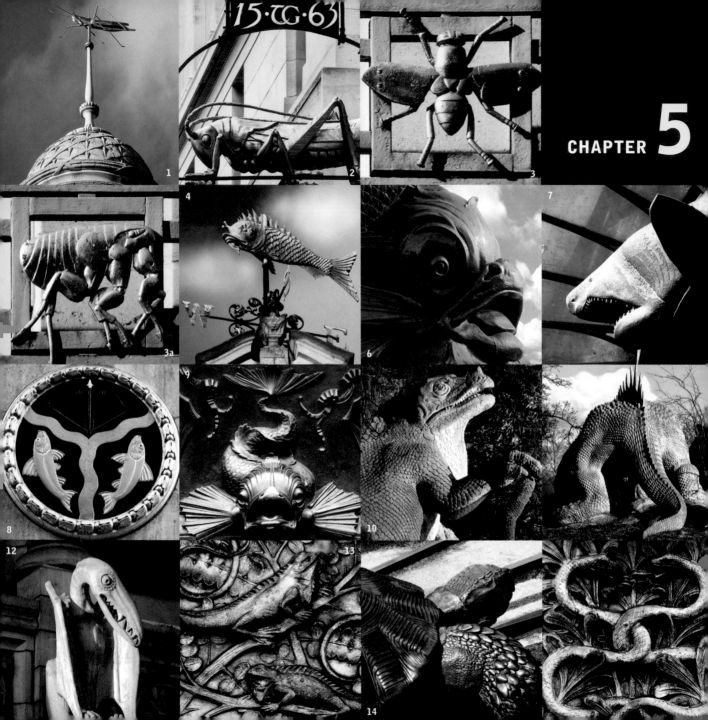

CHAPTER 5

1

2

3

3a

4

6

7

8

9

10

12

13

14

Insects, Fish and Reptiles

The paucity of insect sculptures in London is remarkable. In spite of their astonishing variety and infinite complexity, insects barely feature in the capital's menagerie of animal artefacts. Even the Natural History Museum, opened in 1881, with its wondrous array of terracotta flora and fauna designed by Alfred Waterhouse, only displays a few insects, which decorate inconspicuous air vents in the basement.

True, insects, with their alien-looking features, are not exactly cuddlesome. But the scarab beetle was held sacred in ancient Egypt and the Chinese regarded cicadas as symbols of rebirth or immortality. Londoners, however, evidently regard them as pests, and it is in this unflattering role that they appear on the balcony of the London School of Hygiene and Tropical Medicine. The only other insect to be found is in the City: a grasshopper emblem of the sixteenth-century merchant and financier Thomas Gresham.

Considering that fish exhibit a greater diversity of species than any other category of vertebrate, you would think that the capital of a North Atlantic island divided by a majestic tidal river would pay more homage to its marine life. But statues of fish seem as scarce as today's dwindling stocks of North Sea cod. One rare reminder of London's fishy environs is the scaly duo of gilded piscatorial weathervanes high above the Old Billingsgate Fish Market in Lower Thames Street, where fish was traded from Roman times. Further west, on either side of the Thames, there are cast-iron lamp standards with sturgeons wrapped round the posts.

Contrastingly, reptiles – especially the prehistoric variety – hold a unique place in London, albeit in the leafy suburbs of Sydenham Hill. When the original Crystal Palace was moved from Hyde Park and rebuilt on Penge Common after the Great Exhibition of 1851, a park was specially designed to display a permanent exhibition of extinct animals. The project's creator, Benjamin Waterhouse Hawkins, constructed all the animals with help from his adviser, the celebrated biologist and palaeontologist Sir Richard Owen. Unveiled in 1854, it contained the first dinosaur sculptures in the world and pre-dated Charles Darwin's *On the Origin of Species* by nearly six years.

1 **Golden grasshopper, Royal Exchange Building, the City**

This spindly-legged gilded grasshopper, emblem of Thomas Gresham (1519–79), has presided over successive Royal Exchange buildings since before the Great Fire. The insect was a play on his surname, a corruption of the Old English *græs* ('grass') and *ham* ('homestead' or 'settlement') derived from his Norfolk estate. Gresham founded both the Royal Exchange and Gresham College.

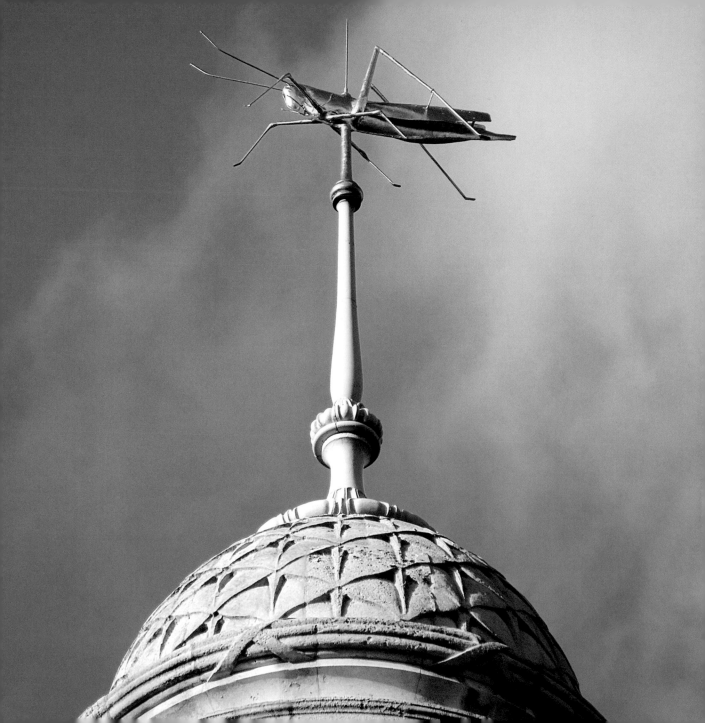

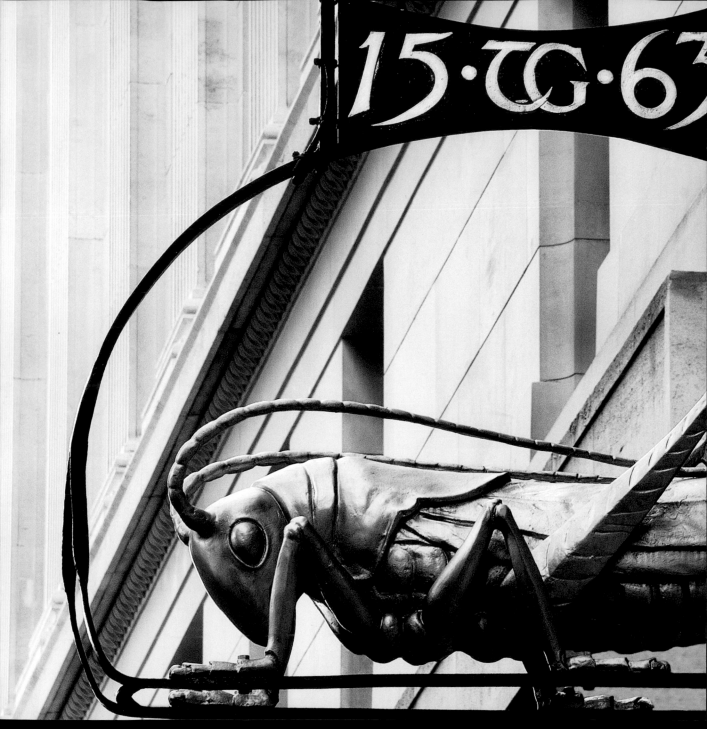

2 Grasshopper, 6 Lombard Street

Once the site of Thomas Gresham's London house, this grasshopper crest is inscribed with the date 1563, the year Gresham offered to build the Royal Exchange at his own expense.

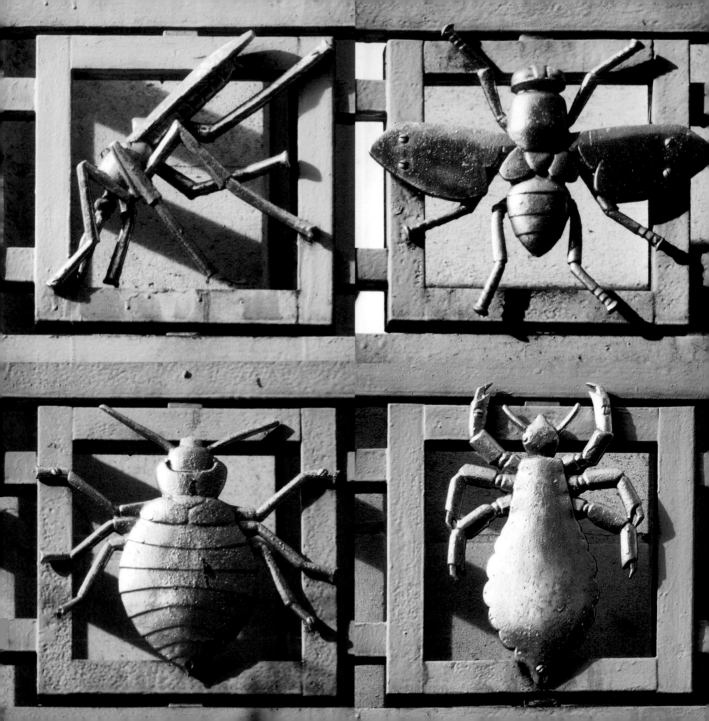

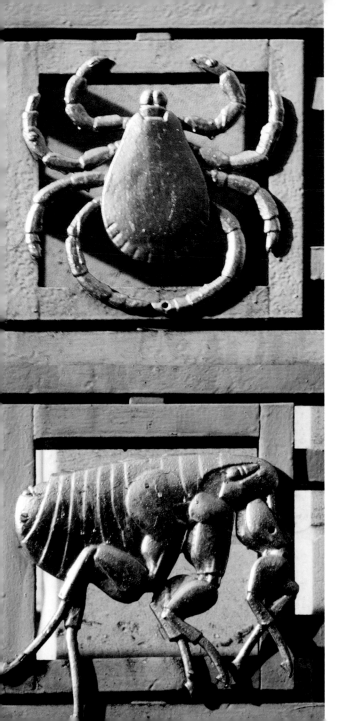

3 Gilt insects, London School of Hygiene and Tropical Medicine, Camden

Running at intervals along the front balcony of the Keppel Street building, these insects remind us of their less than salubrious reputation. Represented here are (top row l–r) a mosquito, a fruit fly, a tick, and (bottom row l–r) a bedbug, a louse and a flea.

4 Fish weathervane, Old Billingsgate Market, Lower Thames Street

Sir Horace Jones, the famous market architect, designed this building in the 1870s when it was still a thriving fish market. This pair of weathervanes on the roof have borne witness to many changes as the old fish market was transformed into a corporate venue, with fishing boats and market traffic giving way to chauffeur-driven limousines.

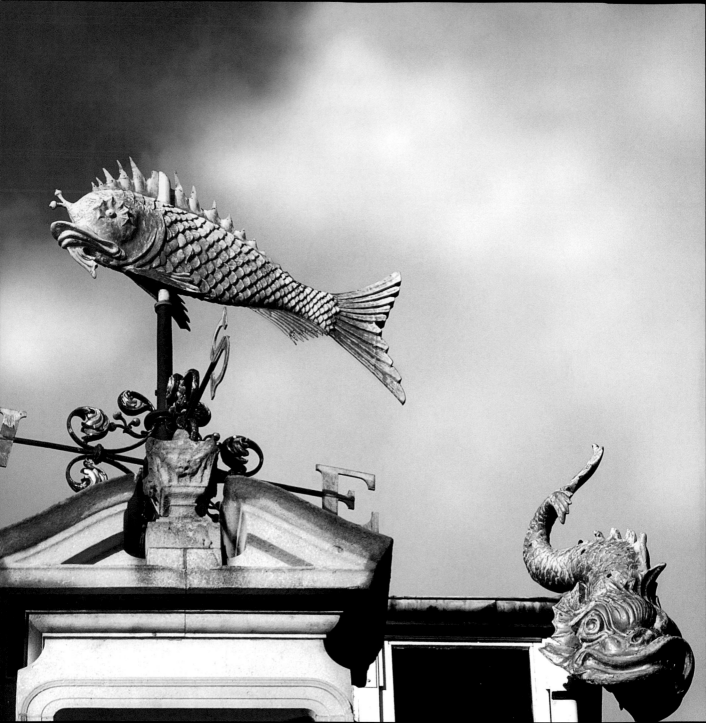

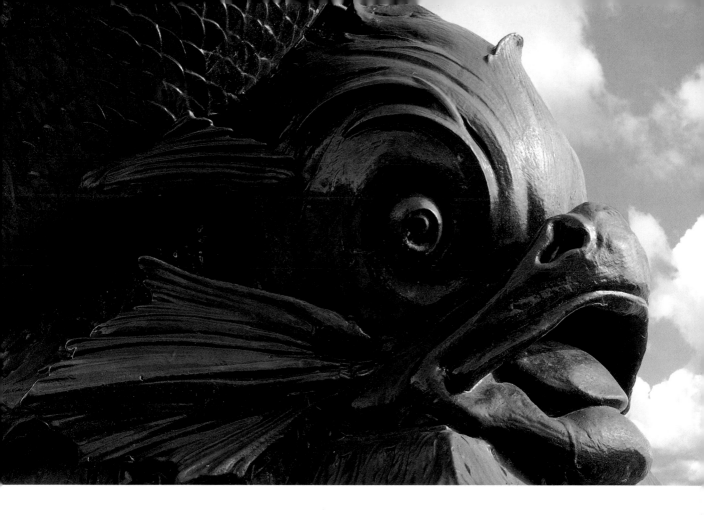

5 Cast-iron sturgeon lamp standards, Victoria Embankment

Victoria Embankment was the first place in London to be illuminated by electric light. The lamp standards with their globe-like lanterns were designed by C.H. Maybey in the 1870s. New ones were added in 1933 and 1964.

6 Detail of sturgeon lamp standard

Together with the lion moorings and the camel seats along the Embankment, the lamps are part of the 'tidying-up' operation in the 1870s that followed the creation of the city's modern sewage system by Sir Joseph Bazalgette.

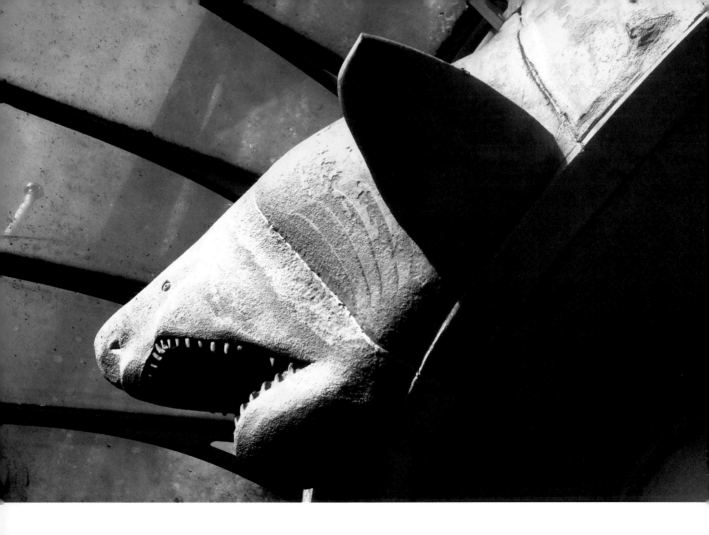

7 Detail of a shark, Allington House, Victoria Street

Designed by Barry Baldwin in 1997, the overhang above the entrance also contains an elephant, a tiger and an ape.

8 Fish roundel, India House, Aldwych

Here symbolizing the United Province of Agra and Oudh, the two fish stand for good luck, and the bow and arrow refer to Rajput traditions.

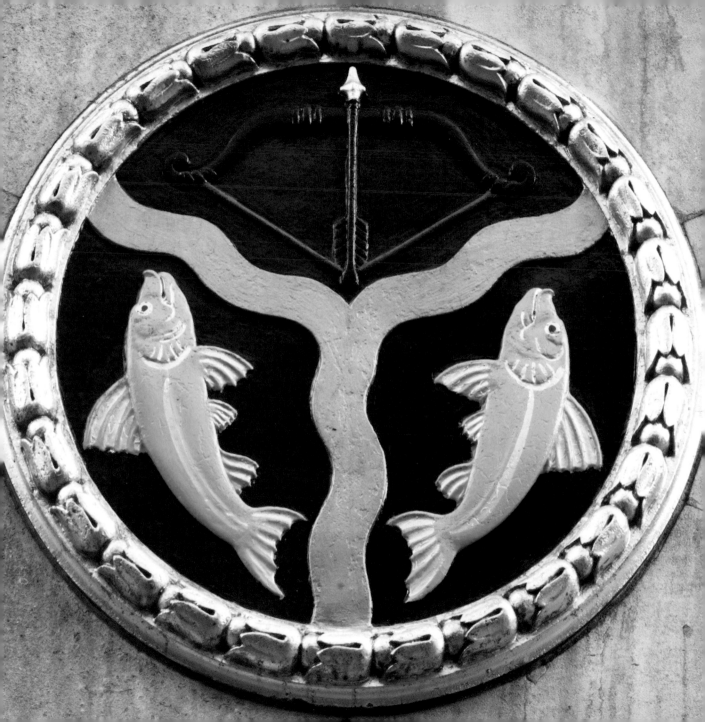

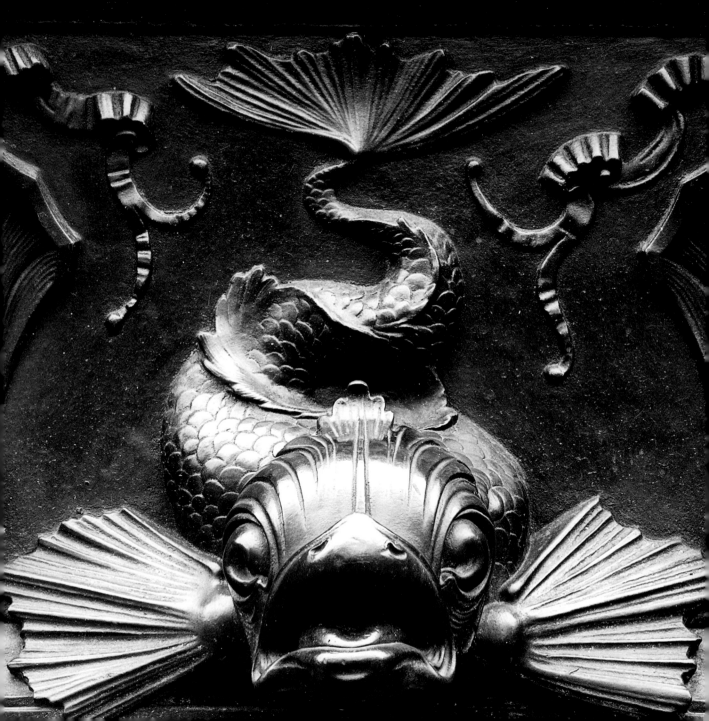

9 Sturgeon on Henry Fawcett's Memorial, Victoria Embankment Gardens

Blinded in a shooting accident at the age of twenty-four, Henry Fawcett (1833–84) was a political economist and MP. He became Postmaster General in 1880, and was a dedicated campaigner for women's suffrage.

10 Iguanadon, the Dinosaur Park at Crystal Palace, Sydenham

One of thirty-three life-size models of giant lizards commissioned from Benjamin Waterhouse Hawkins and unveiled in 1854. On New Year's Eve 1853 Hawkins held a grand dinner inside one of the two iguanadons to celebrate the 'launch' of his models.

11 Hylaeosaurus, the Dinosaur Park at Crystal Palace, Sydenham

The park was so successful that it led to what might be considered the first ever case of tie-in merchandizing with the reproduction of smaller versions sold for £30 as educational props. So began the world's great love affair with dinosaurs.

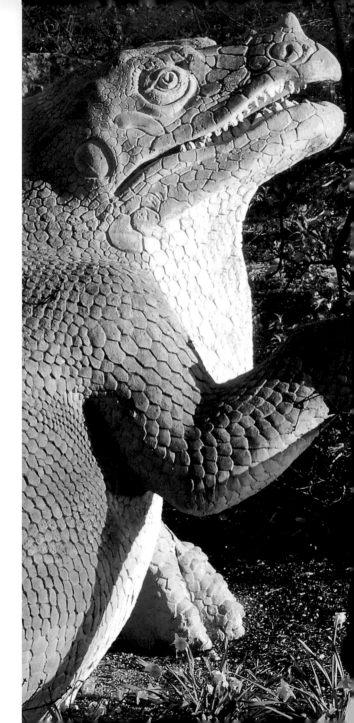

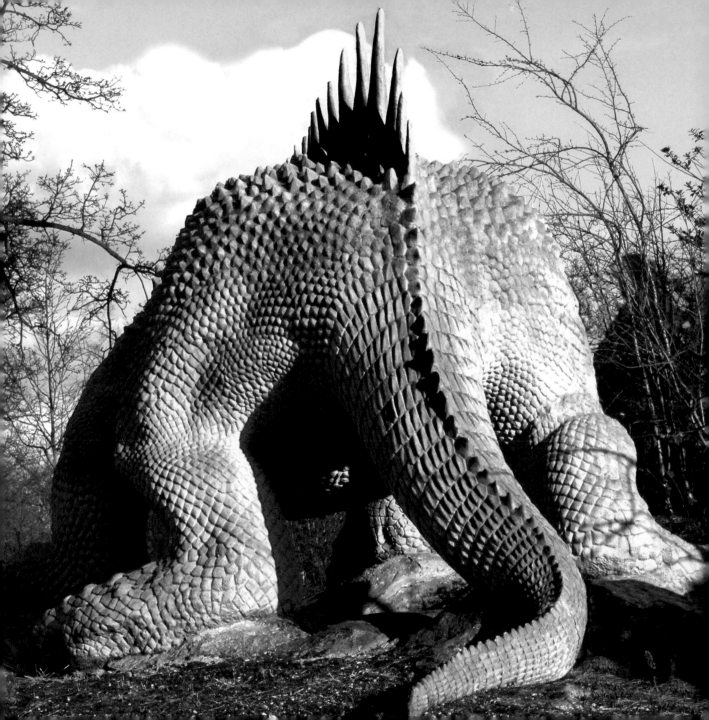

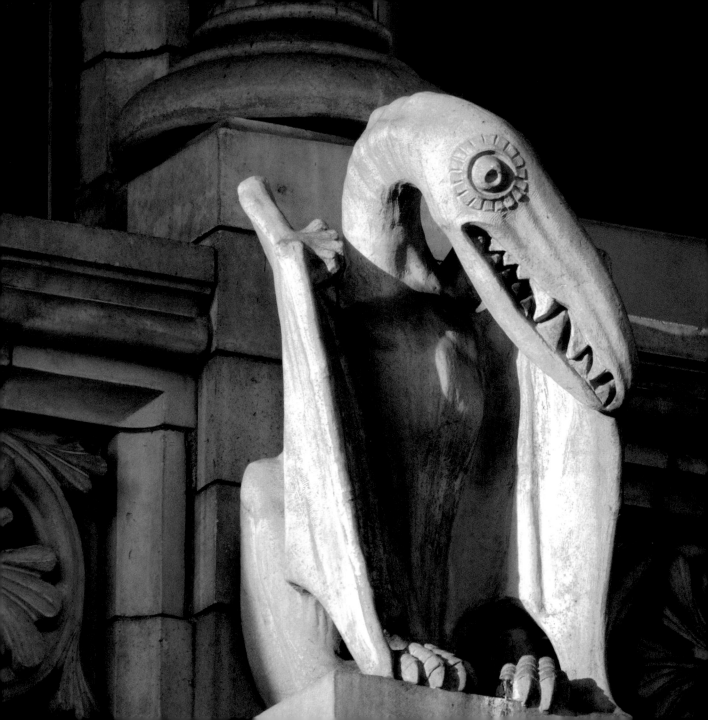

12 Pterodactyl, Natural History Museum, South Kensington

On the east front, this is one of many statues adorning the entrance of the museum. Alfred Waterhouse made three hundred sketches for the sculptures – often from specimens supplied by Sir Richard Owen, the palaeontologist and first director of the museum (though it is doubtful that he had a pterodactyl specimen).

13 Chameleons, Natural History Museum, South Kensington

The museum, sometimes known as the Cathedral of Nature, was the first and largest building to be completely faced in terracotta. This relief is on the stone gateposts.

14 Tortoise sundial, Holland Park, Kensington

This sculpture, by Wendy Taylor titled 'Tortoises with Triangle and Time' (2000), shows two tortoises facing each other from across the bronze lines which define the hours. The female carries the gnomon (or pointer) of a sixteen-foot-high sundial on her back while the male calls to her from the hour markers.

15 Entwined snakes, Natural History Museum, South Kensington

The architect Alfred Waterhouse passed his sketches on to Farmer and Brindley, the terracotta manufacturers, where the sculptor Dujardin made clay models of the animals before they were cast in terracotta. These snakes are on the gateposts.

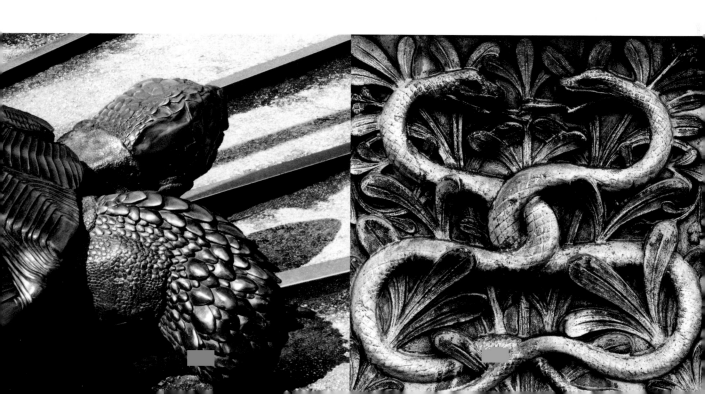

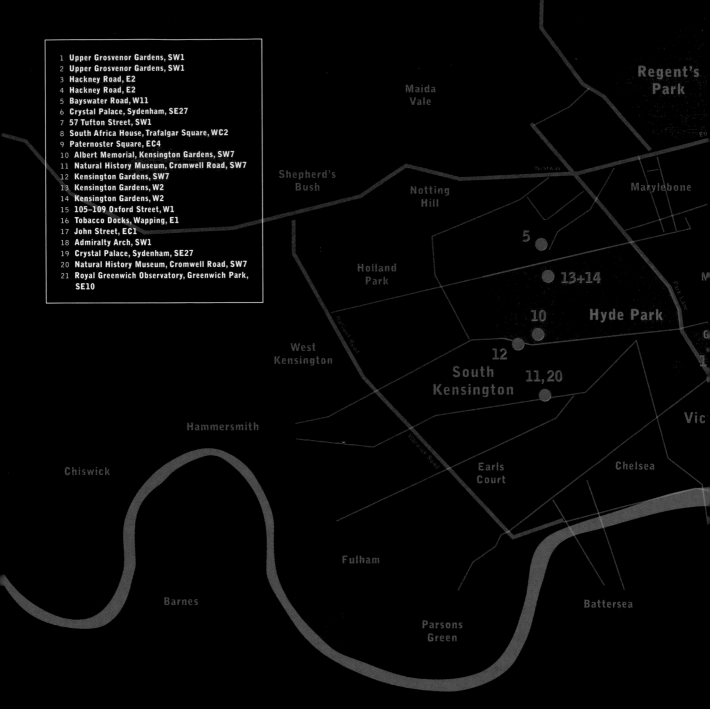

1 Upper Grosvenor Gardens, SW1
2 Upper Grosvenor Gardens, SW1
3 Hackney Road, E2
4 Hackney Road, E2
5 Bayswater Road, W11
6 Crystal Palace, Sydenham, SE27
7 57 Tufton Street, SW1
8 South Africa House, Trafalgar Square, WC2
9 Paternoster Square, EC4
10 Albert Memorial, Kensington Gardens, SW7
11 Natural History Museum, Cromwell Road, SW7
12 Kensington Gardens, SW7
13 Kensington Gardens, W2
14 Kensington Gardens, W2
15 105–109 Oxford Street, W1
16 Tobacco Docks, Wapping, E1
17 John Street, EC1
18 Admiralty Arch, SW1
19 Crystal Palace, Sydenham, SE27
20 Natural History Museum, Cromwell Road, SW7
21 Royal Greenwich Observatory, Greenwich Park,
 SE10

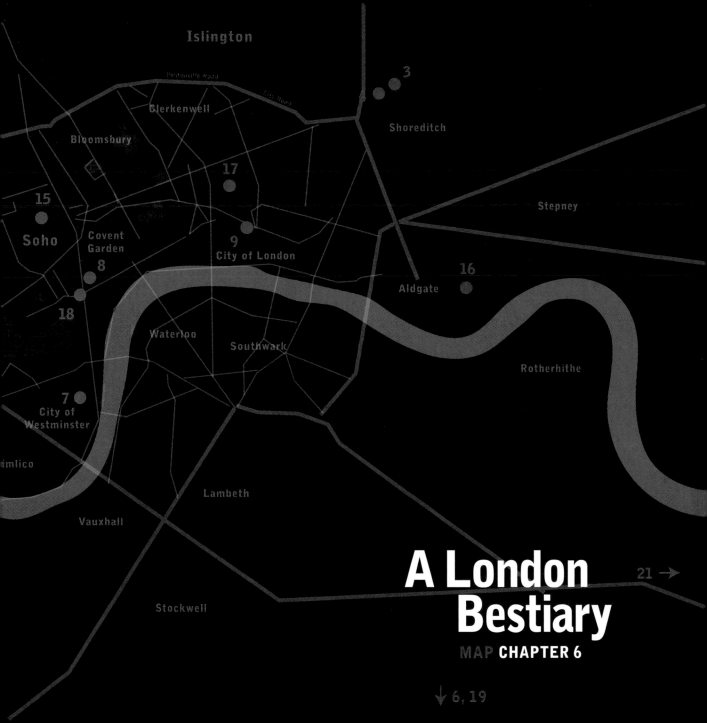

Islington

Pentonville Road

City Road

Clerkenwell

Bloomsbury

3
4

Shoreditch

17

Stepney

15

Soho

Covent
Garden

9
City of London

8

16

Aldgate

18

Waterloo

Southwark

Rotherhithe

7
City of
Westminster

imlico

Lambeth

Vauxhall

A London
Bestiary

21 →

Stockwell

↓ 6, 19

CHAPTER 6

A London Bestiary

If you look hard enough, almost any animal you can think of can be found somewhere in London. Some are where you might expect them – in parks and gardens (and even roundabouts) – whilst others are in more obscure spots. The diversity of settings and materials is almost as great as the variety of animals portrayed: bronzes and different hued marbles stand majestically in wide, open spaces; stone statues perched on gables provide hospitality (not to mention bathroom facilities) to pigeons; terracotta bas-reliefs lend a smile to facades; and brightly painted graffiti bring a theatrical backdrop to busy high streets. The variety is bountiful.

For the main part, the artists who created these creatures have plumped for expressing the animals' intrinsic characters through their observation from nature, rather than endowing them with the moral qualities of good or evil to be found in the medieval bestiaries. Fine, lifelike bronzes include the 'Lioness and Lesser Kudu' (1993) by Jonathan Kenworthy,

in Upper Grosvenor Gardens, and David Wynne's 'Gorilla' (1961) at Crystal Palace. Elizabeth Frink's grave and monumental group of sheep near St Paul's Cathedral in Paternoster Square (1975) brilliantly combines the medieval and modern approaches; she captures her subjects' animal nature whilst at the same time endowing them with the quiet grandeur of holy sheep.

In Hackney, a giant rabbit painted on the side of a building lives just down the road from an enormous beaver, which towers over a semi-derelict car lot. These arresting animals are huge but naturalistic; they appear wild, but are situated in the scruffy urban landscape of Hackney Road; their enormous size gives godlike status to what would otherwise be humble creatures. The settings of these images makes one think of rabbits and beavers quite differently from the way one might in, say, Richmond Park.

The functions of these animals also vary from one to another. Whilst the beaver on Oxford Street and the boar by Smithfield Market advertised merchandise, the Boy and Tiger statue in the Tobacco Docks, Wapping, celebrates an unlikely urban tale.

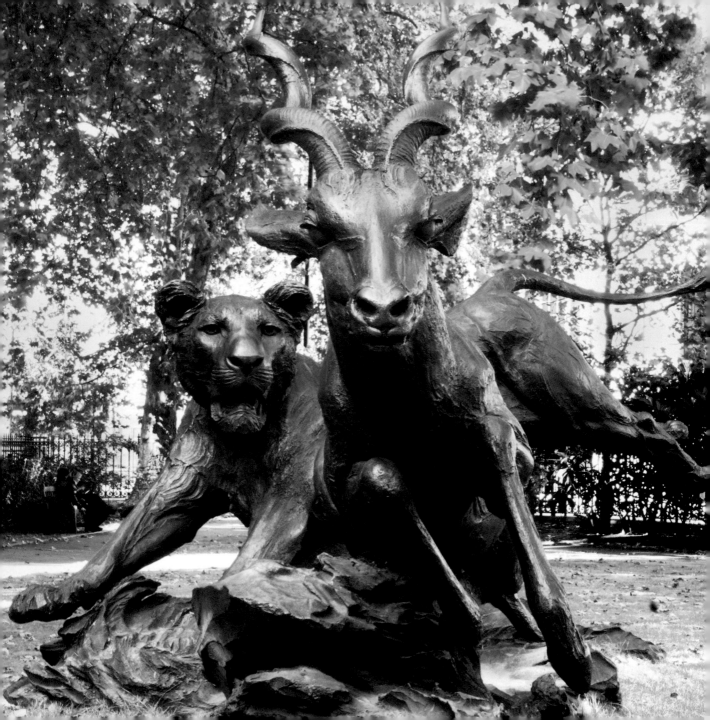

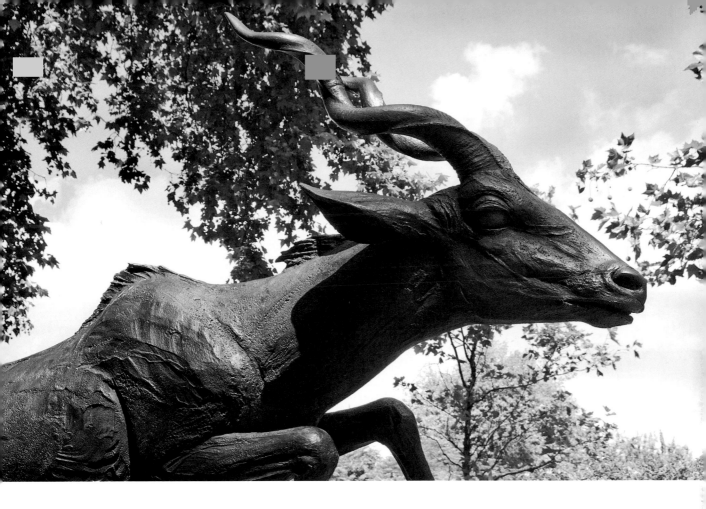

1 **Lioness and lesser kudu, Upper Grosvenor Gardens**

In 1993, Jonathan Kenworthy, well known for his animal sculptures, was asked by the Duke and Duchess of Westminster to create this bronze for a lake at Eaton Hall in Cheshire. A second casting was placed here in 2000 to mark the opening of the gardens to the public.

2 **Detail of lesser kudu, Upper Grosvenor Gardens**

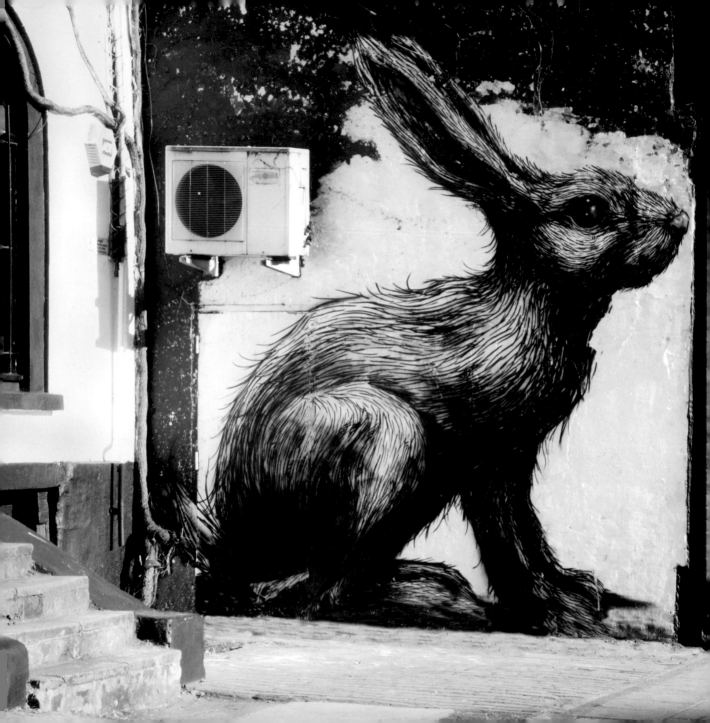

3 **The Roa rabbit, Hackney Road**

Roa, the elusive Belgium graffiti artist, painted this 3.5 metre rabbit on the side of a building called The Premises Music Studios and Café. Although the artist had permission from the owners, Hackney Council ordered them to 'remove or obliterate the graffiti' within fourteen days, or the council would have the wall stripped and charge them for the trouble. After an uproar including a flurry of angry letters and an online petition signed by thousands of Roa's fans, the council climbed down and the rabbit is still in place.

4 Giant beaver in derelict yard, Hackney

Just up the road from the rabbit this even bigger Roa beaver towers above the parked cars and vans in the yard. The effect is quite surreal.

5 Fox silhouette on letterbox, Bayswater Road

Images of foxes have been appearing on walls and other surfaces to complement their growing numbers in the city. It is not unknown for someone returning home from work to find one snoozing on their sofa.

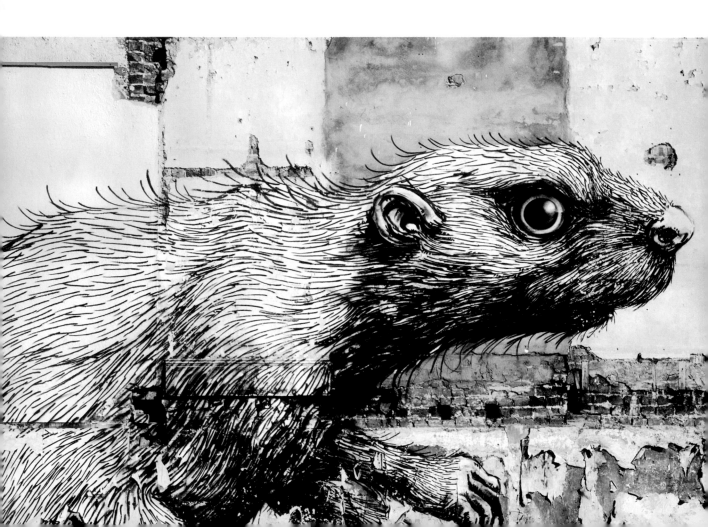

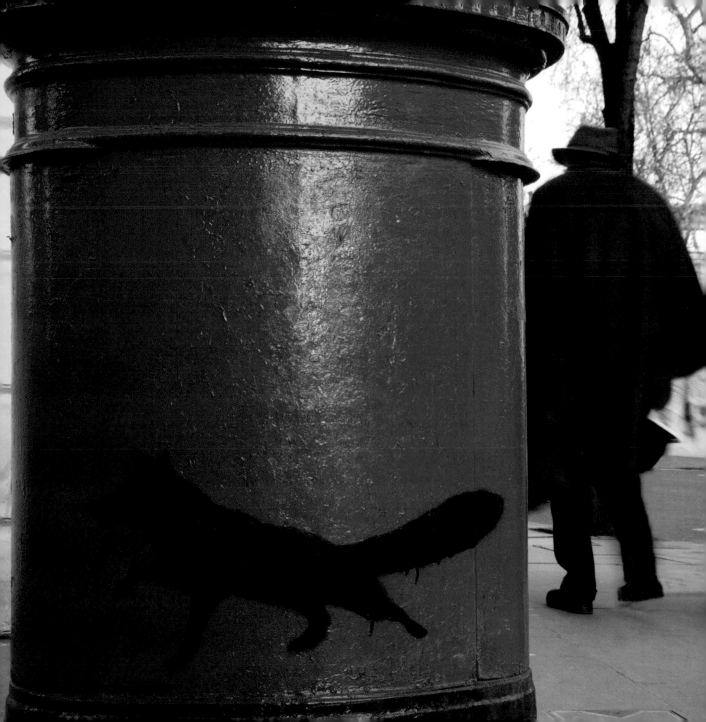

6 'Gorilla', Crystal Palace Park, Sydenham

The source of inspiration for this sculpture was Guy, the famous gorilla at London Zoo. He arrived from West Africa when he was two, and died over thirty years later in 1978. The statue, in black marble with a polished surface, dates from 1961, when David Wynne became absorbed in the task of trying to convey, through his carving, the core qualities of individual animals.

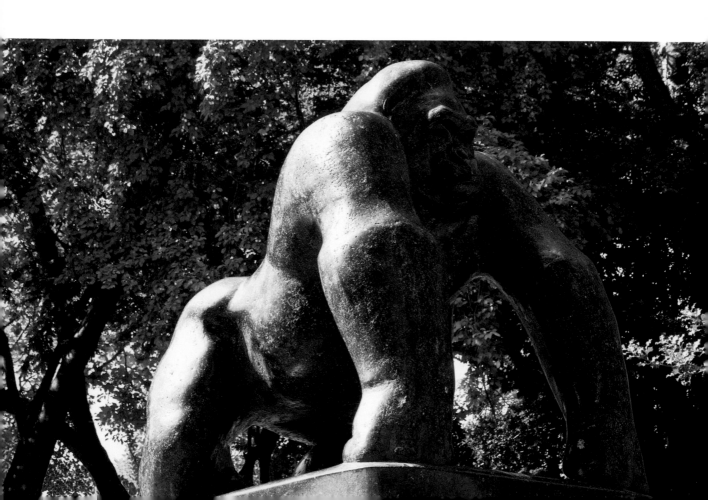

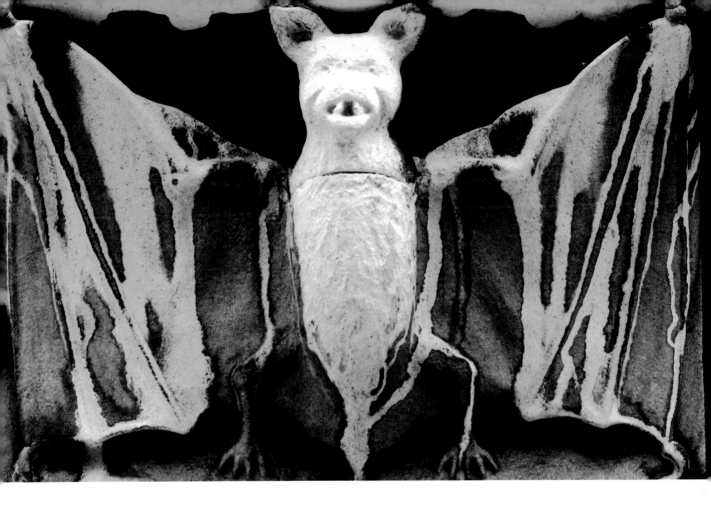

7 **Plaster bat, 57 Tufton Street**

Always the most sinister of the symbols of darkness, in Western cultures they are universally associated with evil and vampires, as in Bram Stoker's *Dracula*. Our medieval ancestors saw them as 'birds of the Devil' because they only emerge from their hiding places at twilight.

Little lumps that fly in air and have voices indefinite, wildly vindictive;
Wings like bits of umbrella.
Bats!
Creatures that hang themselves up like an old rag, to sleep;
And disgustingly upside down.
Hanging upside down like rows of disgusting old rags
And grinning in their sleep.
Bats!
From D.H. Lawrence's poem, 'Bat'.

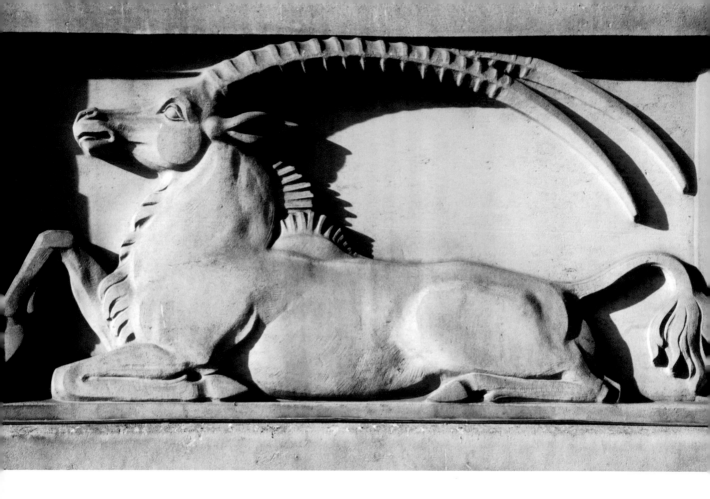

8 **Bas-relief of an antelope, South Africa House, Trafalgar Square**
Designed by Sir Herbert Baker and completed in 1933, South Africa House boasts several ornamental motifs. This one on the facade was carved by Joseph Armitage.

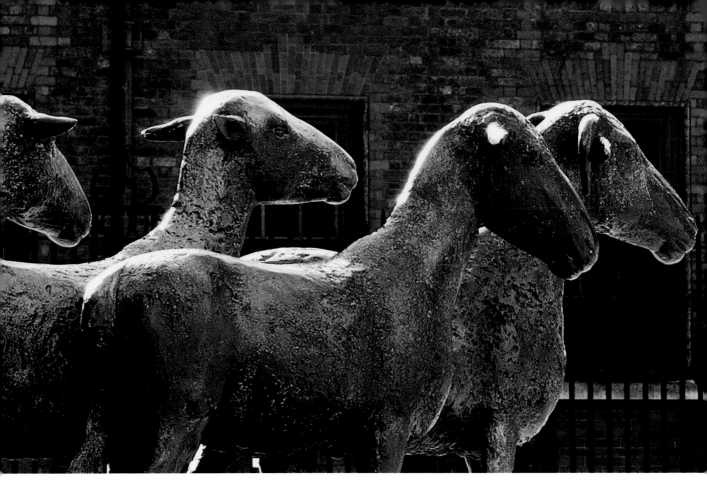

9 **Sheep, Paternoster Square**

Made in fibreglass and bronze, Elizabeth Frink's subject matter honours Paternoster Square's previous history as a livestock market.

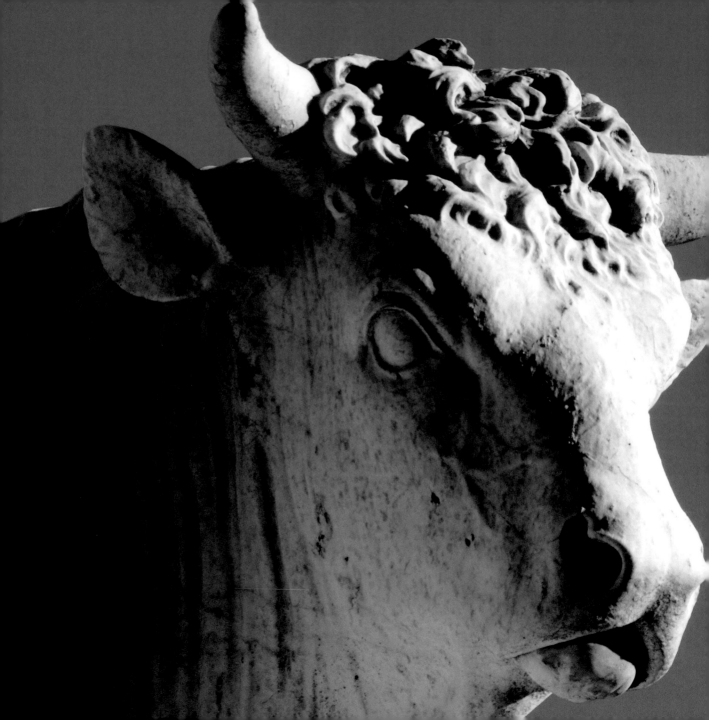

10 **Detail of bull's head from the Albert Memorial, Kensington Gardens**
One of the four marble groups on the Albert Memorial representing the four corners of the British Empire. This bull, sculpted by Patrick MacDowell in 1872, symbolizes Europe.

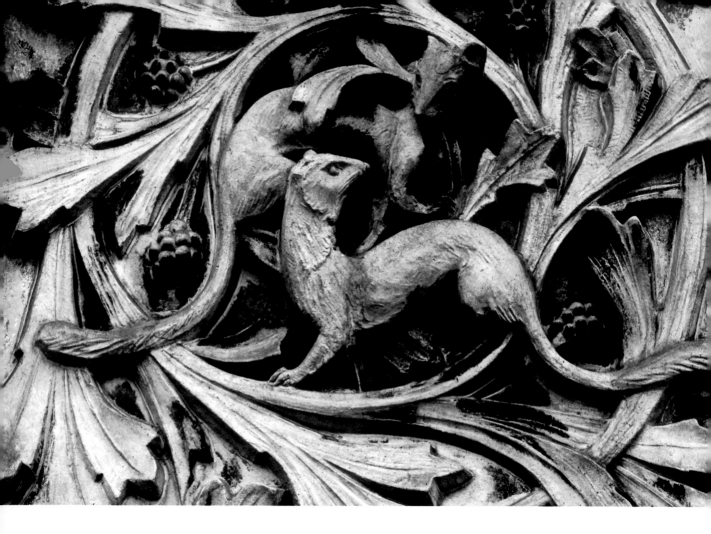

11 Weasels, Natural History Museum, South Kensington

The carvings on the exterior of the building depicted the contents of the museum.

12 A deer and fawn on one of the gate-posts leading into Kensington Gardens

The gardens were originally part of Hyde Park and the statues – one of a pair – may refer to the days when the park was part of a royal chase or hunting enclosure created by Henry VIII. Hyde Park was first opened to the public in 1637.

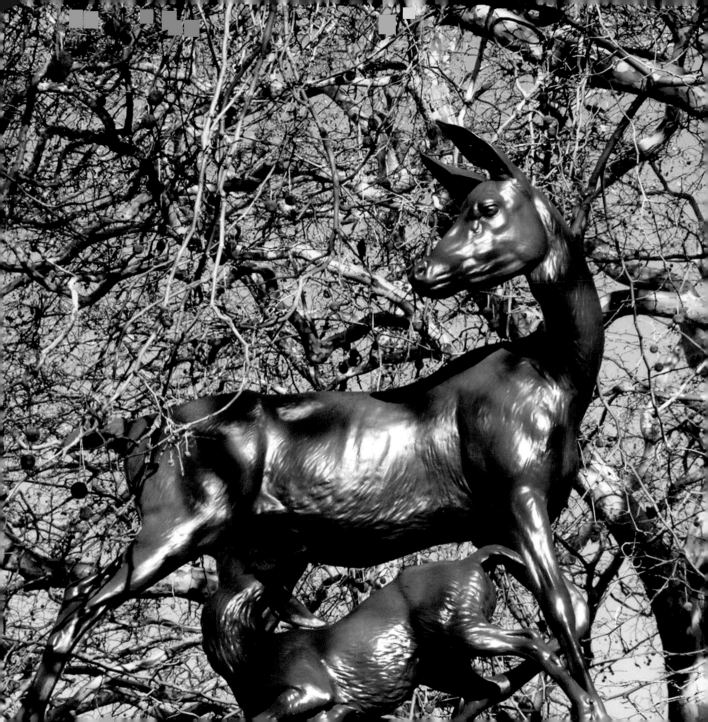

13 Detail of mice from the Peter Pan sculpture, Kensington Gardens

The Peter Pan bronze was commissioned by J.M. Barrie, author of the famous play and book, subtitled The Boy Who Wouldn't Grow Up. It shows him on the stump of a tree blowing his pipe, with fairies and mice, rabbits and squirrels all around.

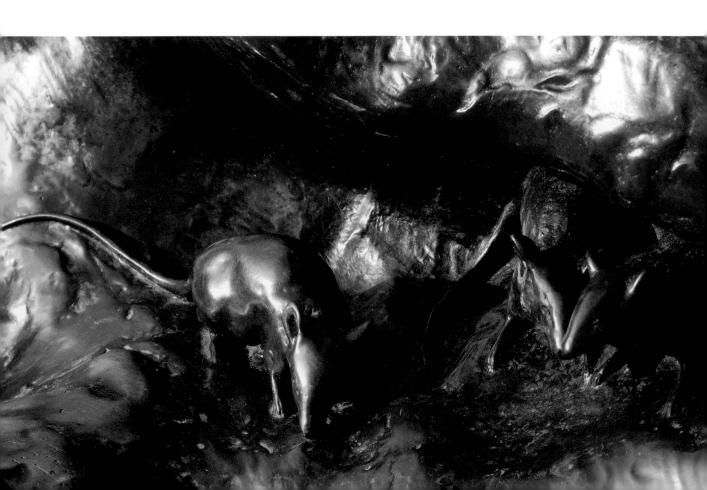

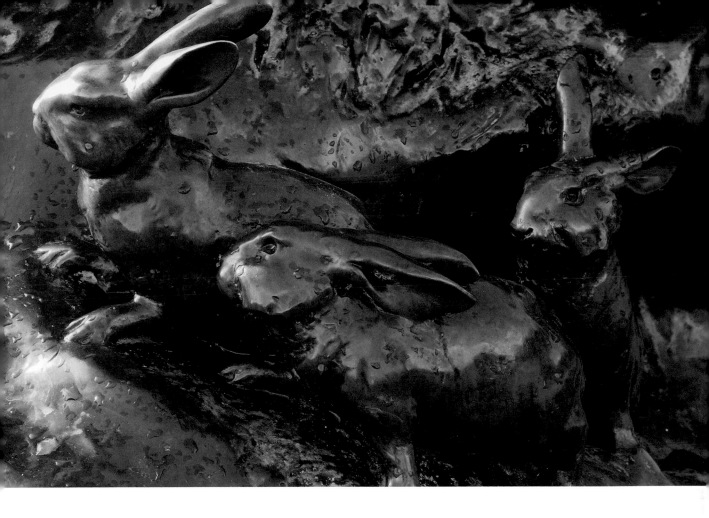

14 **Detail of rabbits from the Peter Pan sculpture**

At the request of both J.M. Barrie and Sir George Frampton, the statue appeared out of the blue on May Day morning, 1912. Barrie announced it for the first time in that day's *Times*: 'There is a surprise in store for the children who go to Kensington Gardens to feed the ducks in the Serpentine this morning…' The location of Frampton's sculpture is the spot in Barrie's enduringly popular drama where Peter – who was able to fly – came to land. The sculpture was intended to give quiet pleasure to nannies and their young charges as they walked or played in the park.

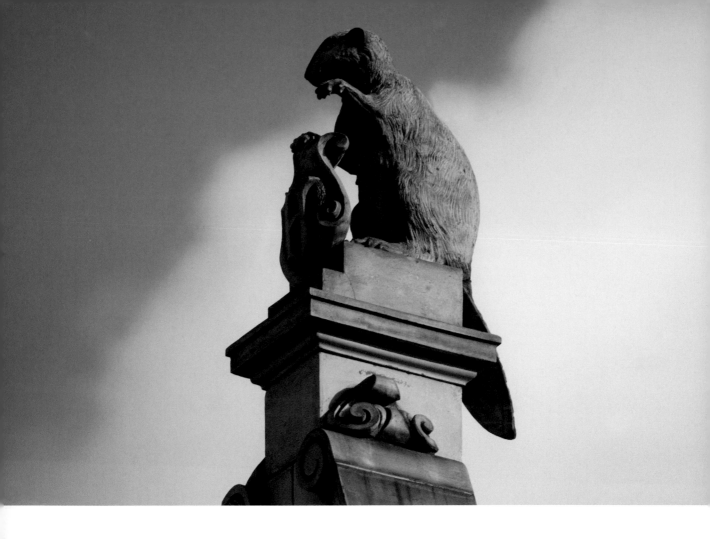

15 **One of several terracotta beavers above the gable of 105–9 Oxford Street**
The building was designed in 1887–8 for Henry Heath, the hatter, who evidently had no qualms about using beaver fur for his creations.

16 Statue of boy and tiger, Tobacco Docks, Wapping

Charles Jamrach (1815–91) was a menagerist who imported wild animals. On one occasion a mature Bengal tiger escaped from its cage and was approached by an eight-year-old boy who, seeing a giant cuddly cat, tried to stroke its nose. After stunning the boy with its great soft paw, the tiger grabbed him by his jacket and proceeded down a side alley. Having discovered the empty cage, Jamrach rushed after the tiger and thrust his bare hands into its throat, forcing it to let go of the boy, who emerged miraculously unscathed. He then led the subdued animal back to its cage.

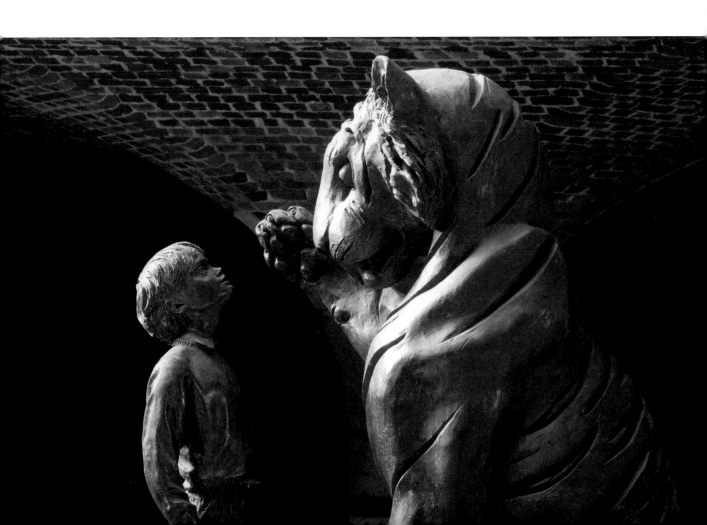

17 Gable with relief of a boar, John Street, adjoining Smithfield Market

William Harris, known as the 'sausage king of London', had this erected above his famous butcher's shop in 1897. Starting business with a little stall in Old Newgate Market, he eventually opened sixty branches in London and became rich. Famed for his eccentricity, he always wore evening dress.

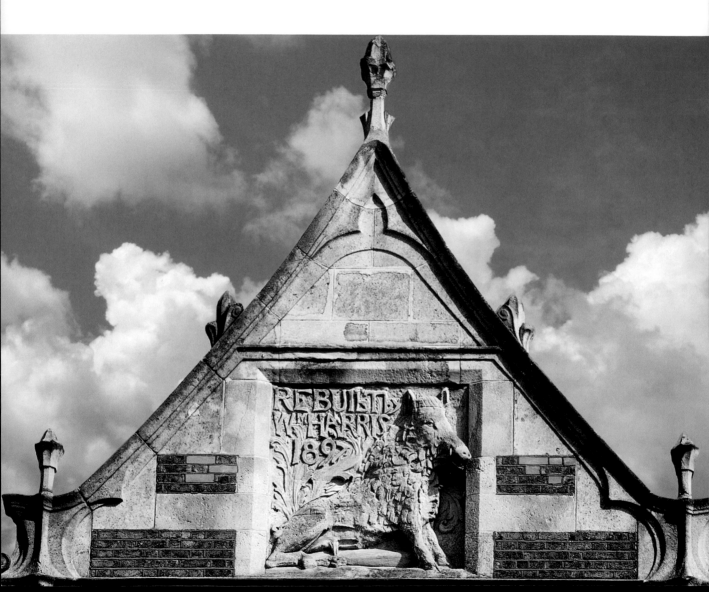

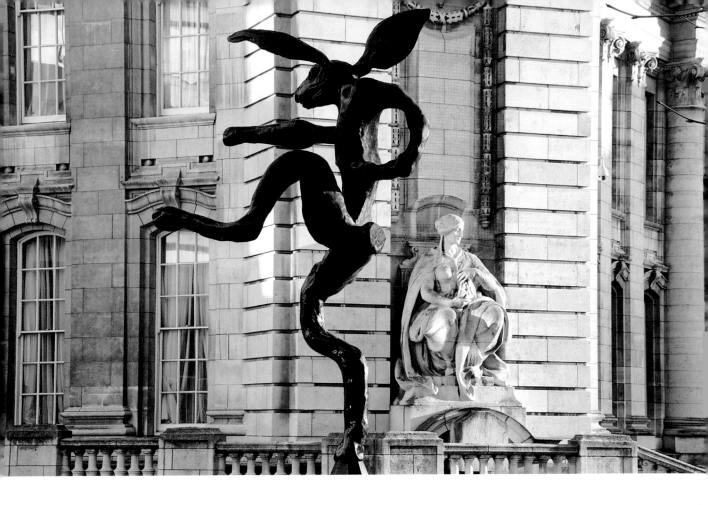

18 Bronze hare, Admiralty Arch

One of a pair of bronze hares cast by Barry Flanagan and erected outside the British Council to mark its seventy-fifth anniversary in 2009, this sculpture, together with its partner, form an imperfect mirror image of a dancing hare. Flanagan, who adopted the hare as his emblem, described the creature as 'rich and expressive, carrying with him the conventions of the cartoon and the investment of human attributes into the animal world ... '

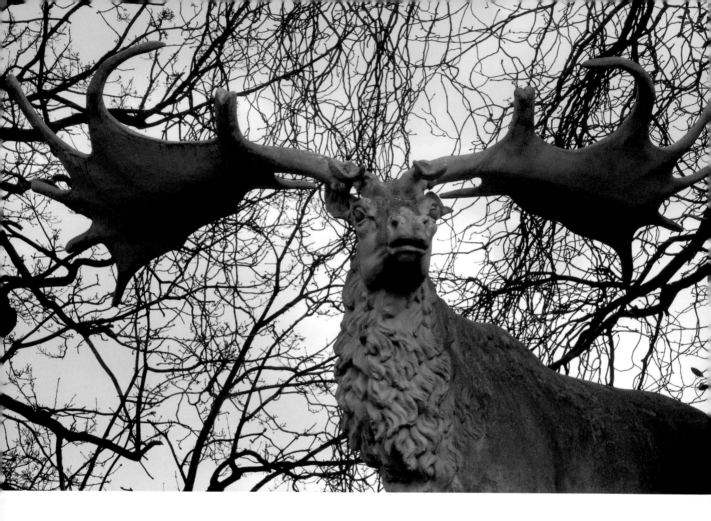

19 Megaloceros, Crystal Palace, Sydenham

Megaloceros means 'giant antler'. Better known as the Irish elk, this handsome creature, with its *Monarch of the Glen* pose, became extinct after the last Ice Age. The statue originally boasted a pair of genuine fossil antlers but these proved too heavy and were replaced with plaster replicas.

20 Wolf, Natural History Museum, South Kensington

This hungry-looking terracotta wolf on the eastern facade is modelled on a drawing by Alfred Waterhouse and seems to be howling at the moon.

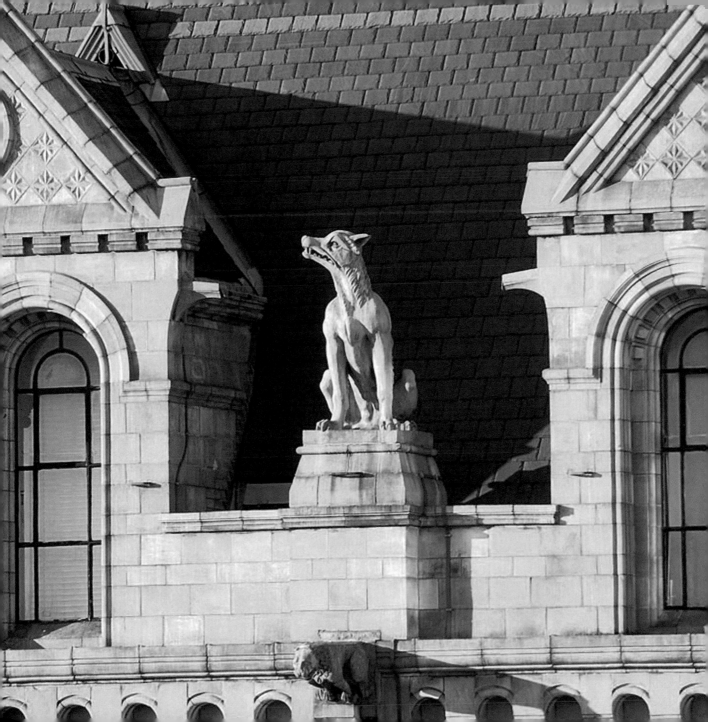

21 **Detail of dolphin sundial, Greenwich Park**
Relocated to the garden of the Old Royal Observatory, the sundial was made by Christopher Daniel for the Queen's Silver Jubilee in 1977. The shadow of the gap between the dolphins' tails denotes the time of day to within one minute.

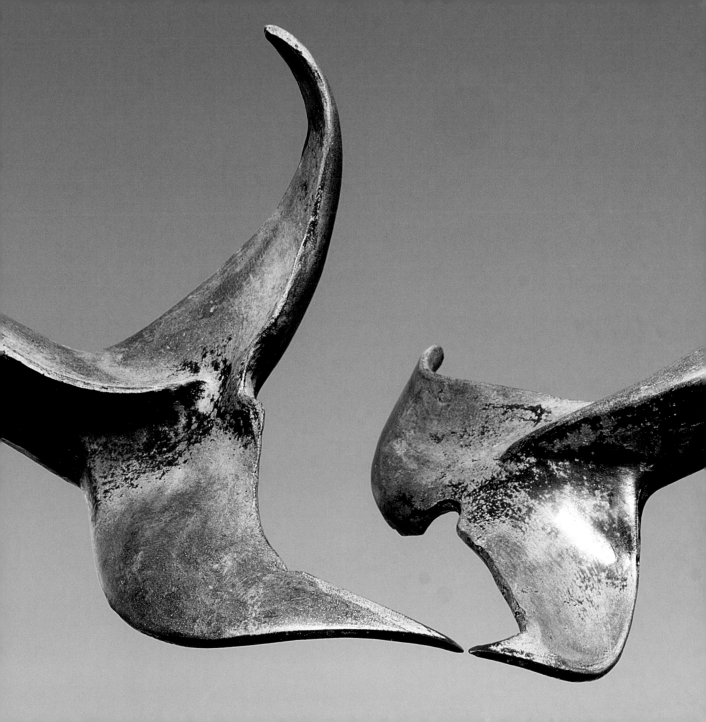

Ianthe Ruthven is a photographer specializing in architecture, interiors and landscape. Her work has appeared in numerous books and magazines, including *Architectural Digest*, *Art and Antiques*, *Country Homes & Interiors*, *The World of Interiors* and other publications around the world. Her previous books include *The Irish Home* and *The Scottish House*. She has had three exhibitions at the National Theatre in London – 'The Atlantic Wall' (2004, coinciding with the sixtieth anniversary of the Normandy Landings), 'Unfamiliar Thames' in 2007 and 'A London Bestiary' (2010), where some of the images in this book originally appeared. Her multiple images of landscapes and the patterns created by sea snails and other marine creatures are in several private and corporate collections.

www.iantheruthven.com

Acknowledgements

The idea for this book grew out of my exhibition 'A London Bestiary' (October 2010) in the Olivier foyer of the National Theatre. I am grateful to John Langley and his team for their help with the show, to Lucy Hughes-Hallett for suggesting the book and to Dan Franklin for making it possible. My thanks also to Matt Fisher for his help with microbes, Anna Crone for so patiently accommodating my whims, Rowan Yapp for keeping me on track and Skimper for his editorial help.

St John's eagle on the Church of the Good Shepherd, Upper Clapton

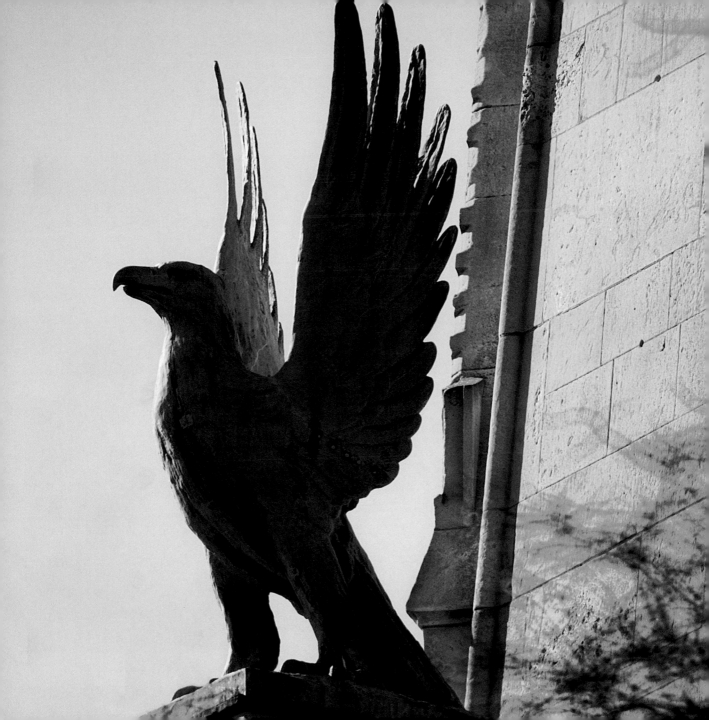

INDEX

– Page numbers in italic refer to photographs

St George's, Bloomsbury, WC1: lion and unicorn *24*, 25, *25*
St Mary le Bow, Cheapside, EC2: dragon weathervane 75, *75*
Sayers, Tom: tomb *38*, 39
Scott, Sir George Gilbert
 Albert Memorial 51
 Westminster School War Memorial 27, *27*
Serjeant's Inn, Fleet St, EC4: dove and serpent roundel 98, *99*
sheep 147, *147*
snakes 133, *133*
South Africa House, WC2: impala 146, *146*
Southwark Cathedral, SE1: gargoyle *84*, 85
sphinxes *88*, 89
sturgeon 113, *123*, *127*
swans 106–107

T

Taylor, Wendy: 'Tortoises with Triangle and Time' 133, *133*
Temple Bar, Strand, WC2: griffin 72, *73*
Temple Place (No. 2), WC2
 bulldog sign 40, *41*
 lion 23, *23*
Theed, William, the Younger
 camel, Albert Memorial *50*, 51
 camel train, Eastcheap 54, *55*
Thornycroft, Hamo: Cromwell 29
tiger 155, *155*
Tobacco Docks, Wapping, E1: boy and tiger 155, *155*
tortoises 133, *133*
Trafalgar Square, WC2: lions 14, *14*, 15
Tufton St, SW1: bat 145, *145*

U

unicorn 90, *91*
Upper Grosvenor Gardens, SW1: lioness and lesser kudu *138*, 139, *139*

V

Vauxhall Cross, SW11: Elephant and Castle statue 56, *56*
Victoria, Queen 14, 81
Victoria Embankment, WC2
 camel seats 52, *53*
 dragon *70*, 71

Imperial Camel Corps Memorial 52, *53*
lion, Temple Place 23, *23*
lion mooring rings *26*, 27
Royal Air Force Memorial 96, 97, *97*
sturgeon lamp standards 122, 123, *123*
Victoria Embankment Gardens, WC2: Fawcett Memorial *126*, 127
Victoria Memorial, SW1: lion 32, 33
Vulliamy, George: sturgeon lamp standards 122, 123, *123*

W

Waterhouse, Alfred
 doves bas relief 98, *99*
 pterodactyl *130*, 131
 weasels bas relief 150, *150*
 wolf 158, *159*
Watts, G. F.: 'Physical Energy; 44, *44*
weasels 150, *150*
Webb, Sir Aston: Victoria Memorial 33
Weller, Rudy: horses of Helios *4*, 9
Westminster Abbey, SW1: lions 20, 20–21, *21*
Westminster Bridge, SE1: Coade lion *16*, 17, *17*
Westminster Hall, SW1: lion under Cromwell's statue *28*, 29
Westminster School War Memorial, SW1 27, *27*
wolf 158, *159*
Wombwell, George: grave *32*, 33
Woodford, James
 falcon 108, *109*
 Yale of Beaufort *88*, 89
Woodington, W. F.: Coade lion *16*, 17, *17*
Worshipful Company of Merchant Taylors, EC1: coat of arms
 62, *62*
Wynne, David
 gorilla 144, *144*
 Queen Elizabeth Gates 22, 23

Y

Yale of Beaufort, Kew Gardens *88*, 89

Z

Zucha (dog) 43